# DOLLS & TOYS OF NATIVE AMERICA

I remember
hands soft and warm, reaching for me.
I remember hands feeding me
from wooden bowls and buffalo-horn spoons.
I remember women's voices,
lullabies crooned softly in my ear
and laughter that fell into my grandmother's lap
as she held me.
And I remember the carved doll my father gave me.
It came from his father and in time
it will be given to my child.

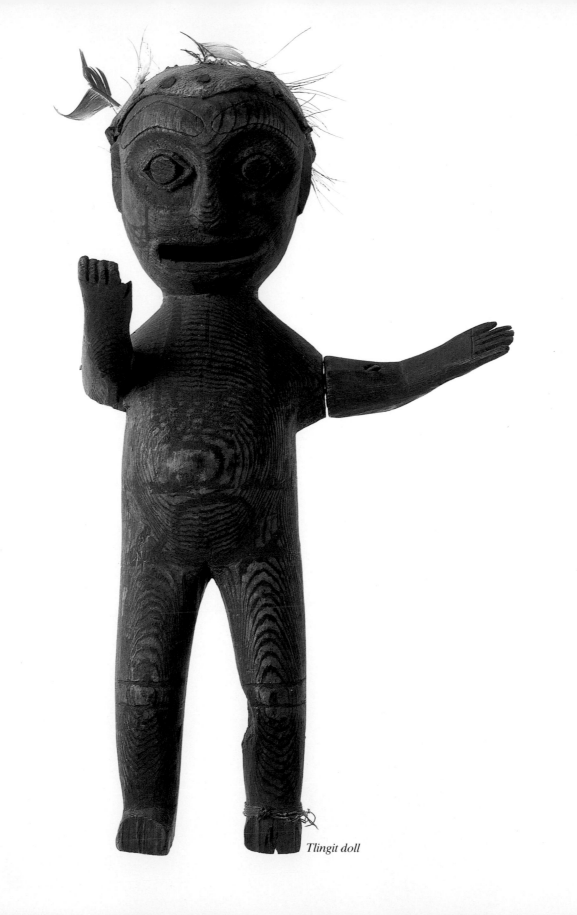

*Tlingit doll*

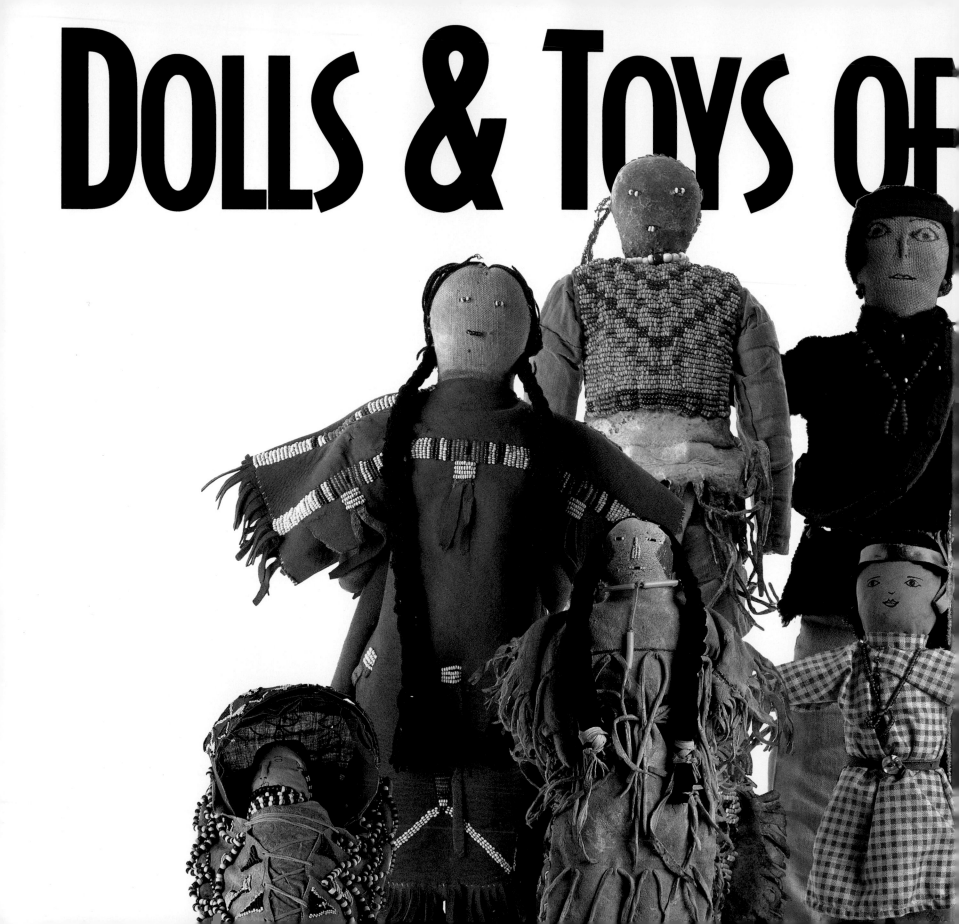

# DOLLS & TOYS OF

# NATIVE AMERICA
## A JOURNEY THROUGH CHILDHOOD

By Don and Debra McQuiston

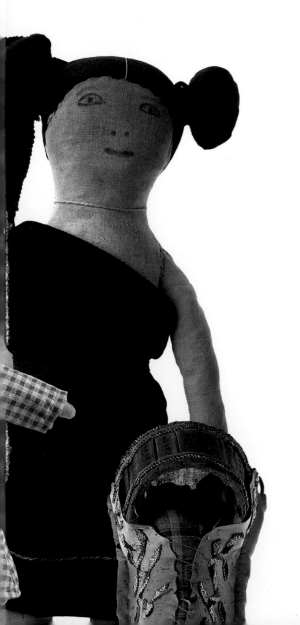

CHRONICLE BOOKS
SAN FRANCISCO

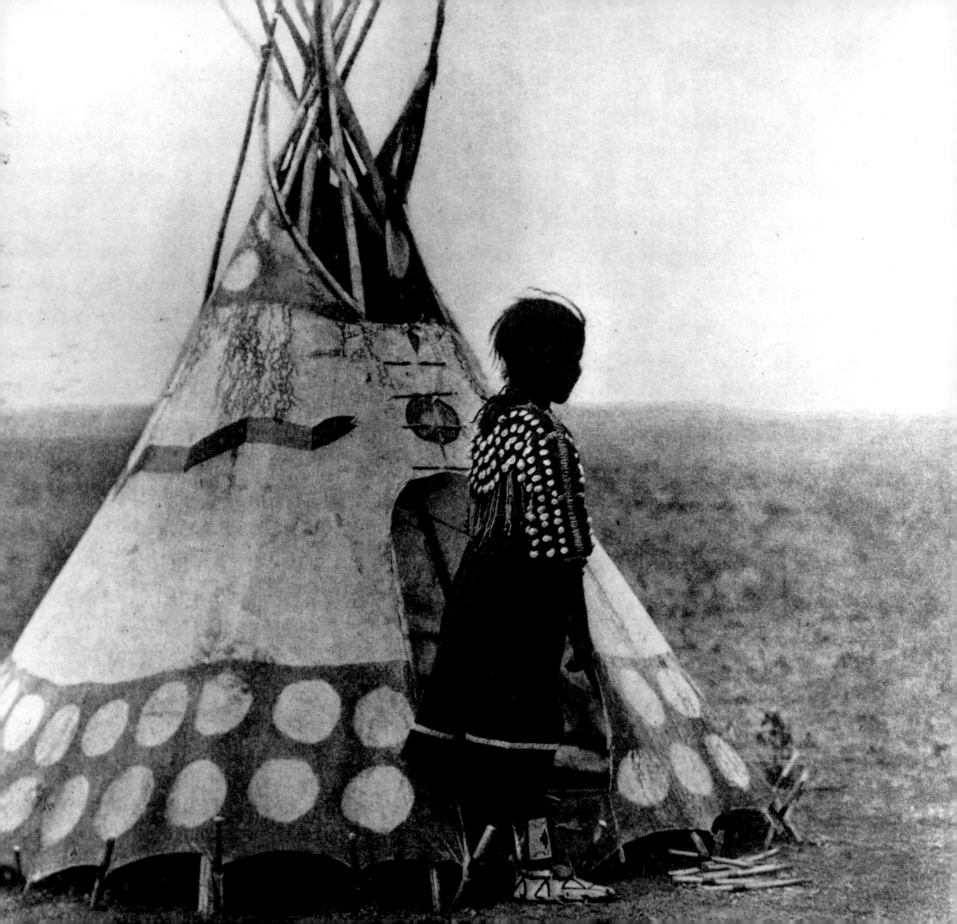

To all children,
who once we were.
They are our life.

Produced by McQuiston & McQuiston; artifact photography by John Oldenkamp; text by Jeremy Schmidt; captions by Jeremy Schmidt and Laine Thom; edited by Lynne Bush; composition by ColorType; printed in Hong Kong by South Sea International Press. San Diego Museum of Man photographic coordination by Grace Johnson.

Library of Congress
Cataloging-in-Publication Data:
McQuiston, Don.
  Dolls & toys of Native America: a journey
  through childhood / by Don & Debra McQuiston.
  p.    cm.
  Includes bibliographical references and index.
  ISBN 0-8118-0572-7  (HC)
  ISBN 0-8118-0570-0  (PB)
  1. Indian dolls  North America.
  2. Indians of North America Recreation.
  3. Indian Children  North America.
  I. McQuiston, Debra.
  II. Title.
  III. Title: Dolls and Toys of Native America.
E98.D65M36 1995
970.004'97  dc20            94-34678
                        CIP

10  9  8  7  6  5  4  3  2  1

Distributed in Canada by Raincoast Books
8680 Cambie Street
Vancouver, British Columbia V6P 6M9

Chronicle Books
275 Fifth Street
San Francisco, California 94103

Printed in Hong Kong

*Piegan Blackfoot child and play tipi*

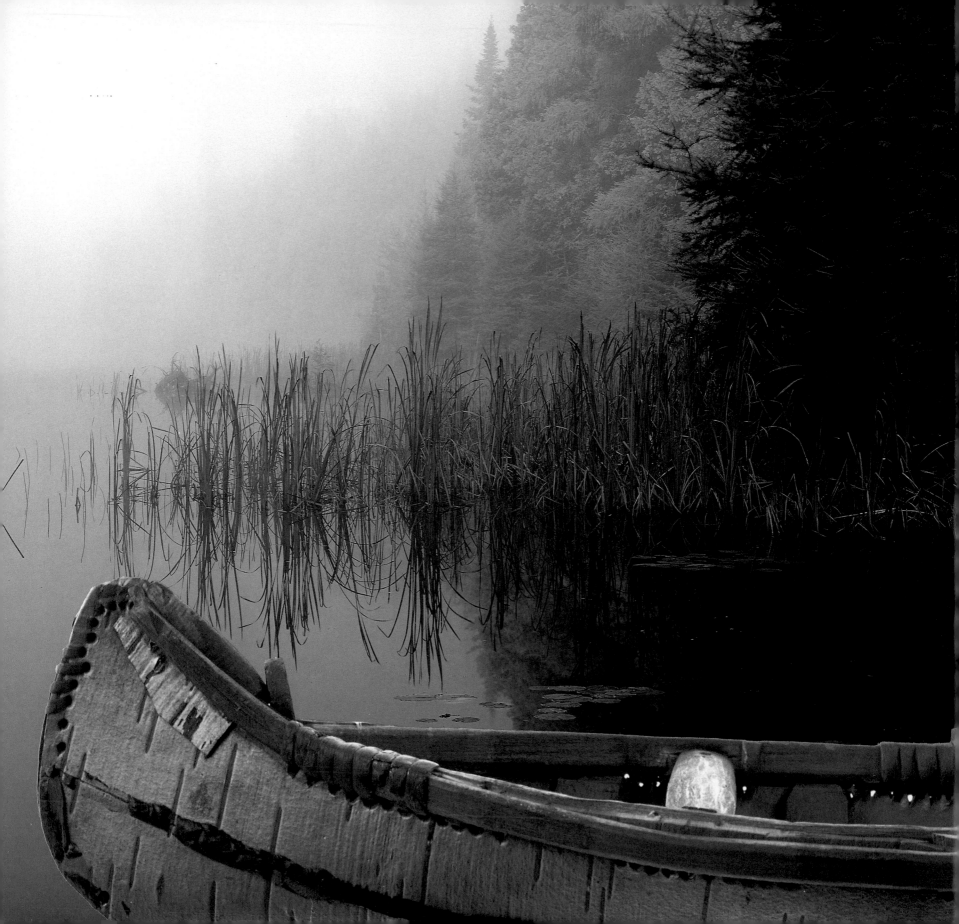

# CONTENTS

*Chippewa toy canoe*

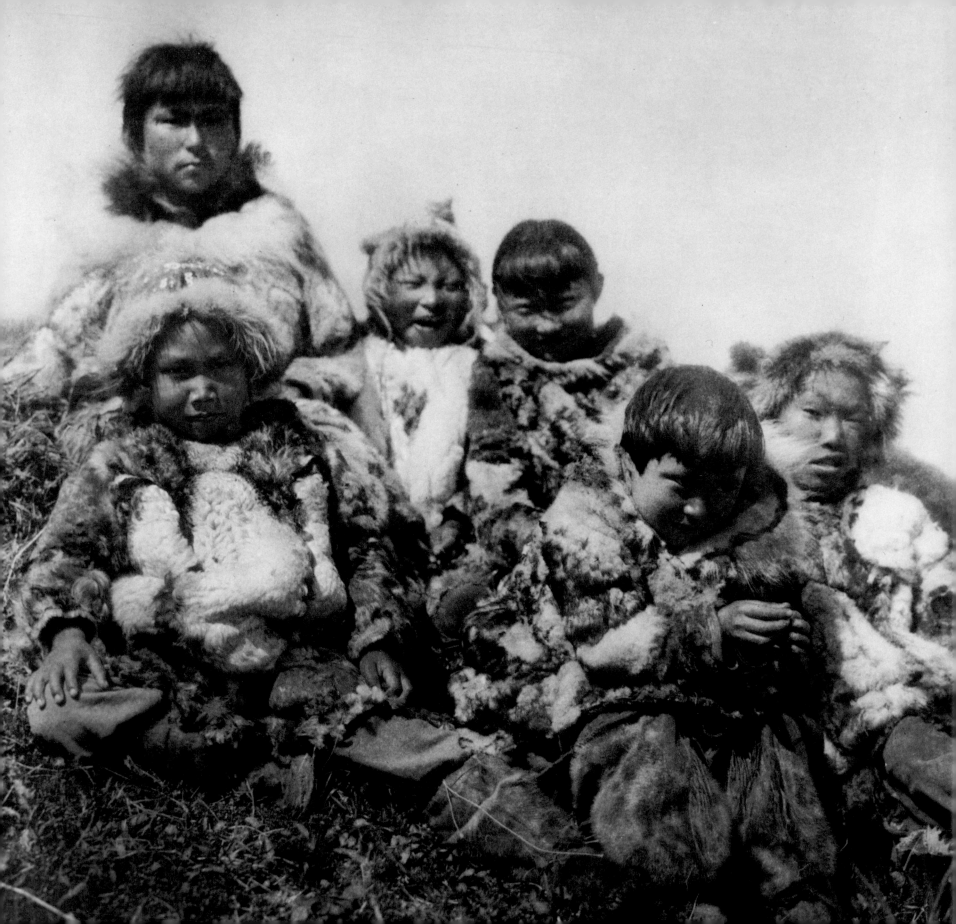

# THE WORLD OF CHILDREN

*Nunivak children*

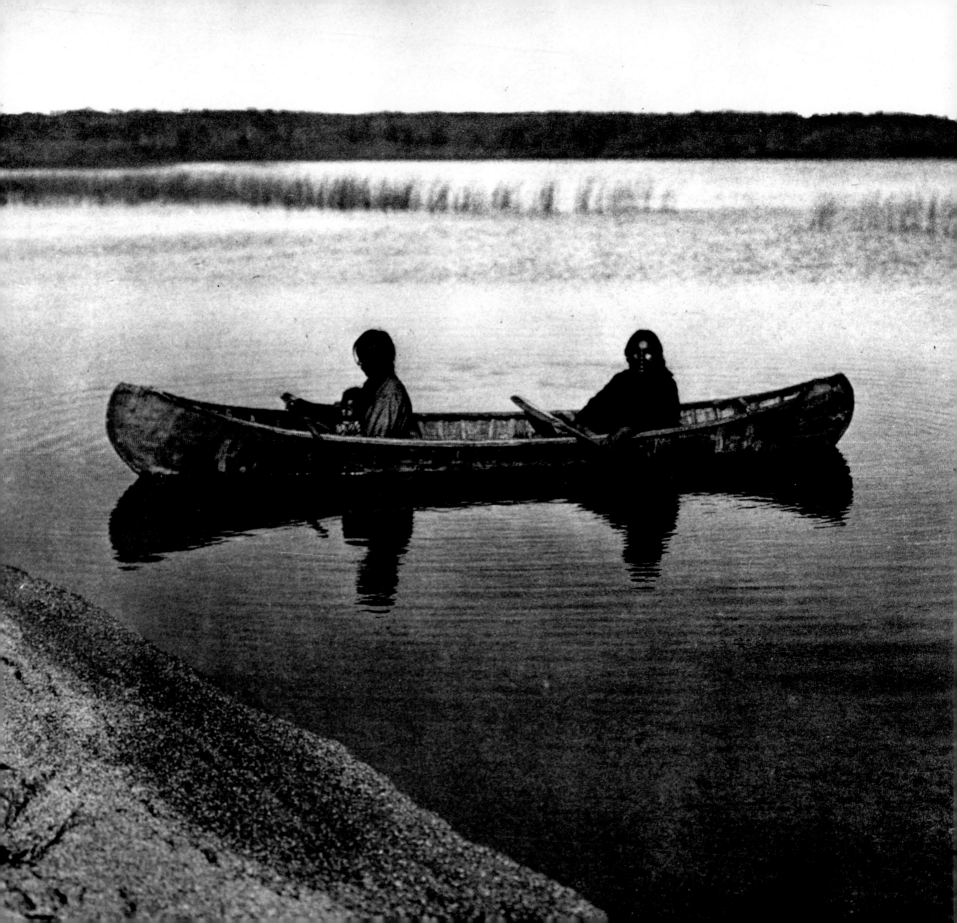

# THE
# WORLD
# OF
# CHILDREN

INTRODUCTION

More than a century ago, a young Cree father sat by a northern lake working a piece of birch bark. It was June. and the forest was green with new growth. The man's son was coming into his third summer. Soon the boy would be the right age to receive his first canoe, a miniature model only 26 inches long.

13

Although the man was making a toy, he paid close attention to the details of its construction. He put in the right number of maple thwarts, bent the ribs from strips of white cedar, and sealed the seams with spruce gum. When finished, the small canoe would be as accurate a model of a real canoe as he could make.

Yet this canoe was more than a simple toy. It carried a burden of history, tradition, design, and practical technique. The Cree thought that if a boy owned a properly made toy canoe, it would help him understand how to build a full-size one; by playing with the toy canoe, he could make imaginary journeys into the realm of adulthood. The same was true on the Great Plains, where Lakota girls

*Cree family*

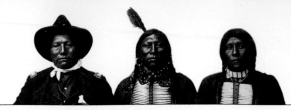

practiced women's skills using toys of a more domestic nature—dolls dressed in deerskin, decorated with beadwork. With the help of parents and grandparents, they would establish their dolls in complete miniature households: small tipis carpeted with animal skins, bags and bundles around their perimeter, cooking gear, cradleboards, and even medicine bundles placed neatly inside. Outside the tipis stood little horses covered with real horsehair, pulling travois on which rode tiny child dolls.

It was play, and it was life. For boys the emphasis was on hunting and war, while girls focused on domestic skills. In either case, the object was to make a clear connection between the play of a child and the work of an adult. At stake was the continuity—and perhaps the survival—of their culture.

Not all toys were models. The Blackfeet, like some other tribes, regarded certain tipi designs as sacred property to be displayed only by those who held the rights to their use. These rights had to be bought, or earned, and then transferred through special ceremonies. The paintings on even a miniature tipi could have great significance, adding to a child's sense of identity—piece of real property that would stay with her all her life.

Naturally, toys reflected local culture. Inuit children had toy dog sleds. Lakota children had toy horses. In the eastern woodlands, infants were given a little leather pouch filled with maple sugar; by sucking and chewing it, they could taste the sweetness inside. In the Arctic, far from any source of sugar, a baby would

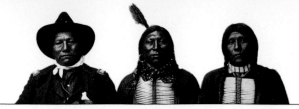

be given a strip of blubber to chew on. It was tied to her wrist with a short thong so that if she began to choke on it, she could flail her arms and yank it out. Did this reflect a hard pragmatism on the part of parents, or was it an early lesson in self-reliance? Perhaps both.

Like toys, stories for children were meant to entertain, but also to educate. Stories were the means by which tribal history and values were passed from one generation to the next. They taught religion. They told of creation. They provided cautionary lessons. They described life as it was meant to be lived, and explained *why* it was meant to be lived that way.

In some tribes, the most important stories were sacred, imbued with spiritual power and reserved for telling only at specified times of the year and then only by certain people. On the northwest coast, where status was determined by one's possessions, stories and songs were personal property. They could be given away, sold, traded, or inherited, but only the owners had the right to tell their stories or sing their songs.

In many ways, growing up in a traditional native community must have been a wonderful life. Children played outside whenever the weather allowed. They could ride horses, go swimming, launch toy boats, build play lodges. Games for boys included target-shooting and practice hunts in pursuit of rabbits or birds. In winter, those who lived in cold climates went sliding on frozen hills, or spun tops on ice, or used curved sticks and rounded rocks to play hockey. Wooden sleds were

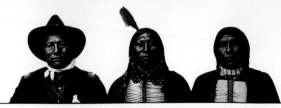

common wherever there was snow, but only on the Great Plains did fathers fashion runners from buffalo ribs.

Although in many activities boys and girls had distinct sex-defined roles (and these became more separate as they grew up), boundaries often broke down when it came to running games and agility contests. Eight-year-old boys had no advantage over girls of the same age in activities like horseback riding, swimming, and running.

Children were always surrounded by the activities of daily life. With the entire family living in one space—be it a tipi, snow house, a room in a southwest pueblo, or a compartment in a bark-covered longhouse—few details or events escaped their notice. They learned from direct experience with adults. In place of formal schooling, they received admonitions and advice from parents, grandparents and others. Theirs was a rigorous education. Although they read no books, they read the sky for weather signs, they read the tracks of animals, and they read the sacred symbols of their religion. They were "literate" in a way different from us, and many of their reading skills are lost to us today.

The presence of grandparents enriched the lives of children, who were taught to respect old people for their knowledge and their spiritual power. Among some tribes, it was common for a grandparent to raise one of his or her grandchildren. Such children were called "old people children" and they bridged the generational gap. In general, grandparents lavished affection on children, telling them stories,

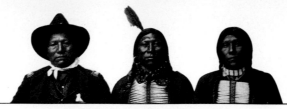

making them toys, often indulging their smallest whims, but grandparents also could provide the most severe lessons. A parent having trouble with a child might call in an elder to deliver a fierce lecture or warning story. Reinforced by the power of age, the words of grandparents carried much weight.

The degree of autonomy granted to native children might surprise modern parents. In a range of matters, the opinions and feelings of a child had the same weight as those of an adult. On the other hand, the child was born into a framework of sometimes rigid social expectations. Life would be a continual attempt to balance individual freedom with tribal responsibilities.

Tribal responsibilities began with initiations, the most important milestones in the lives of native children. Many things were learned on a casual basis, but other aspects of a culture could be transferred only in a formal setting through the special rites of initiation. Designed to mark stages of advancement toward full adult membership in a tribe, the ceremonies reinforced the rank of a people's most important values and traditions. Initiations formalized the transfer of knowledge and culture from the older generation to the younger—passing the keys not through books and laws but through stories, songs, techniques, and traditions. Anything not retained in the memories of tribal elders was lost. By  the same token, any lore not transferred to the young was forever gone. At stake was nothing less than the continuity of a culture.

Such was the cargo borne even by a toy canoe.

17

# N

ative
children grew up in the embrace of an extended
family—parents, grandparents, uncles and
aunts, all of whom had a hand in the raising of
youngsters. A child soon learned that a
18  mother's role was keeper of the family dwelling
place and that a father's role involved
hunting, protecting his family, and conducting
religious rituals. Children were brought up to

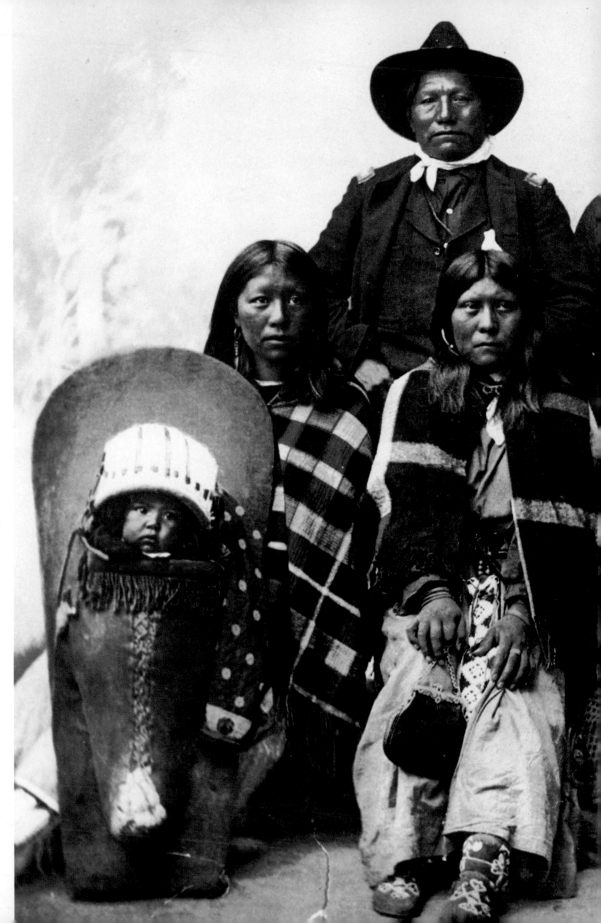

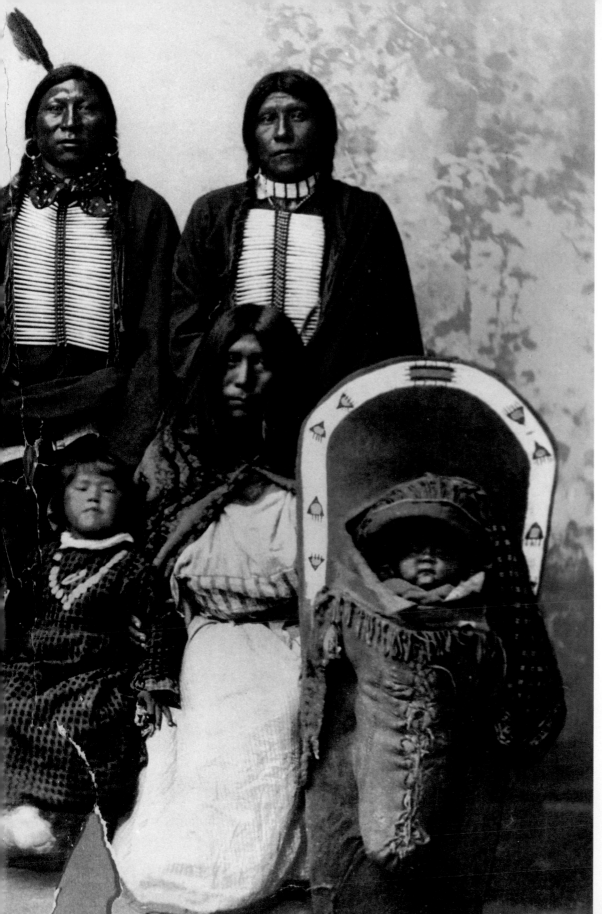

respect all members of the tribe, including themselves, and to hold in reverence the earth upon which they and all other creatures lived. This respect required that children follow proper rules of conduct, especially when there was serious conversation among the elders, whom they were taught to respect above all others. Here, a Ute family poses formally for a frontier photographer.

19

*Ute family portrait*

*The Blackfeet were the quintessential nomads of the
northern plains. They lived (and still live) just east of the
Rocky Mountains in Alberta and Montana. Like
other tribes who roamed the shortgrass prairie—the Sioux,
the Pawnee, the Crow, and the Arapaho—they owed
much to the arrival of horses. Previously their only beasts of
burden were dogs. Horses gave them true mobility,
allowing them to follow the great herds of buffalo for long
distances. While the chase might take them almost
anywhere, they often returned to favorite camps. The men
involved themselves with hunting and warfare and
the choosing of camps, but the women and girls did the
actual work of packing up in one place and re-
establishing their homes at a new one.*

# A DOLL OF BEADS AND BUCKSKIN

A BLACKFOOT TALE

During late summer, in what we
now call Montana, Siski-Aki's
band of Blackfeet camped
beneath a high basalt cliff
beside the Hungry Bear
River. It was a pleasant campsite,
and after three days of riding
beneath the hot August sun,
the delicious shade of cotton-
wood trees felt to SiskiAki like
a pool of green water. The air was delicious.
She wanted to drink it.

As they approached the campsite, SiskiAki
glanced around. She had the feeling she had

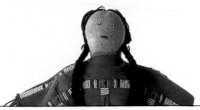

been here before, but couldn't remember when. This was no surprise. Her people moved with the seasons, always on the lookout for good hunting, or good grass for their horses, or a sheltering stand of trees in the winter. They moved frequently, sometimes on a moment's notice, and it was easy to forget some of the places she had been.

Of all the camps, those of late summer were her favorites. August was usually a fat season, a time of ripe berries and well-fed buffalo, and this year had been one of the best. Hunting had been good. Her infant son was healthy. Her first daughter was just old enough to ride her own horse. And thanks to a successful raid led by her husband against the neighboring Crows, there were plenty of horses to ride.

Within minutes of arriving at the river, she set up her tipi poles. Then, arranging the family belongings inside the open framework, she enlisted the help of several other women. Together they pulled the buffalo-hide cover taut and staked it down around the perimeter. As quick as that, a bundle of sticks and skins became a home, familiar and comfortable. Hers was a sacred painted tipi, decorated with symbols her husband had earned in battle, and it always made her proud to see it standing in the circle of the village.

Having done that, she took a leather bucket and walked to the river, where clear water riffled past boulders and slid laughing through gravely shallows. Kneeling to fill the bucket, she was struck by the combination of smells and sounds, and suddenly it came back to her. She had done this before, in this very place. It was *this* camp, *this* one! It had been in the spring, when she was barely more than a toddler. Her people had endured a thin winter. Everyone was hungry, and when scouts thundered into the camp with news of buffalo a day's ride to the north, the men leaped for their hunting equipment while the women rushed around packing up the camp. In the excitement,

22

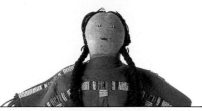

SiskiAki had left behind a small, cherished item—one whose loss had caused her little heart enormous sorrow.

Now she remembered. Hurrying back from the water, she set down her bucket at the tipi and ran up the slope to the base of the cliff. Sure enough, among the tumbled lava rocks she found the cave-like hollow, a child-sized place into which a grown woman could barely squeeze her shoulders. Yet she managed, and there she found it: dressed in buckskin, decorated with beads, her long-lost doll. It stood just as she had left it, leaning against the rock wall, surrounded by the stones and twigs and bits of hide she had used to furnish her playhouse.

SiskiAki had made the doll herself, wrapping strips of leather around a frame of twigs, and fitting it with a doeskin dress like the one her mother wore. Her mother had guided her, showing her how to cut the leather, how to sew the pieces, and finally, how to make it look pretty with blue and white beads.

She had been proud of this doll. Finding it again was like recovering a piece of her childhood. She squeezed back out of the cave and sat holding it in the bright sunlight. This had been her first attempt at beadwork, and it showed. Her mother must have praised her, just as she now praised her own daughter for work no less clumsy.

She could hear her daughter now, calling from the camp below, wondering where she had gone. It would be a nice surprise to give her this old doll. Yet she hesitated. It had been here so long, and so many things had changed for SiskiAki. The doll belonged more to the past than the present. It seemed more fitting to leave it there, presiding over a cavern playhouse in the world of memory. Besides, her daughter was just finishing the beadwork on a doll of her own. SiskiAki turned, replaced the doll in the cave, and walked down the hill.

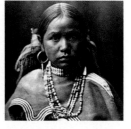

23

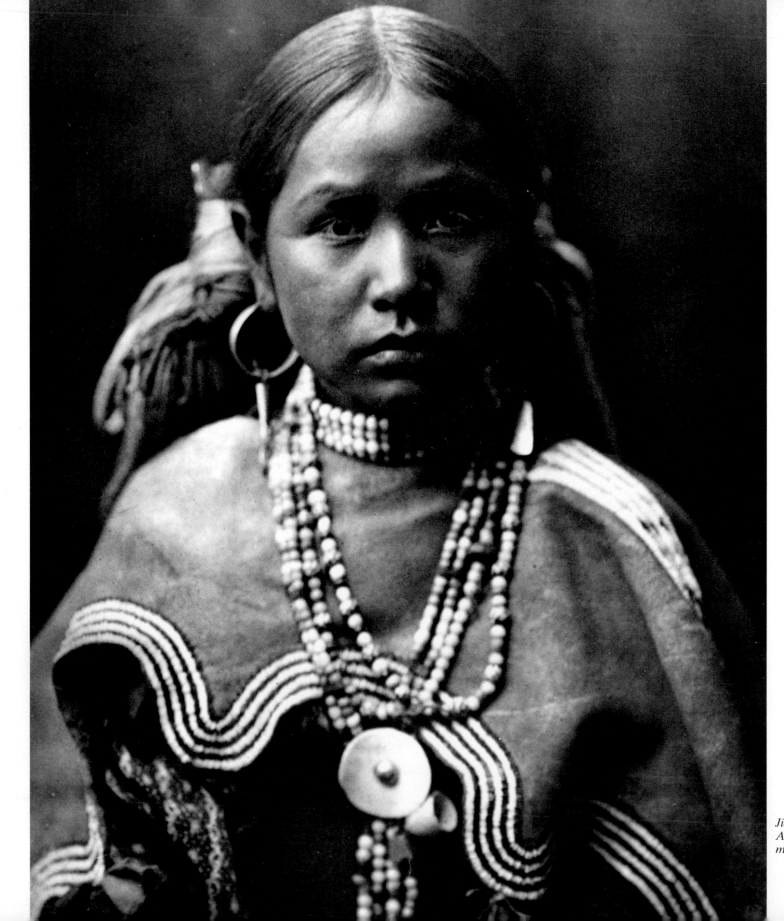

24

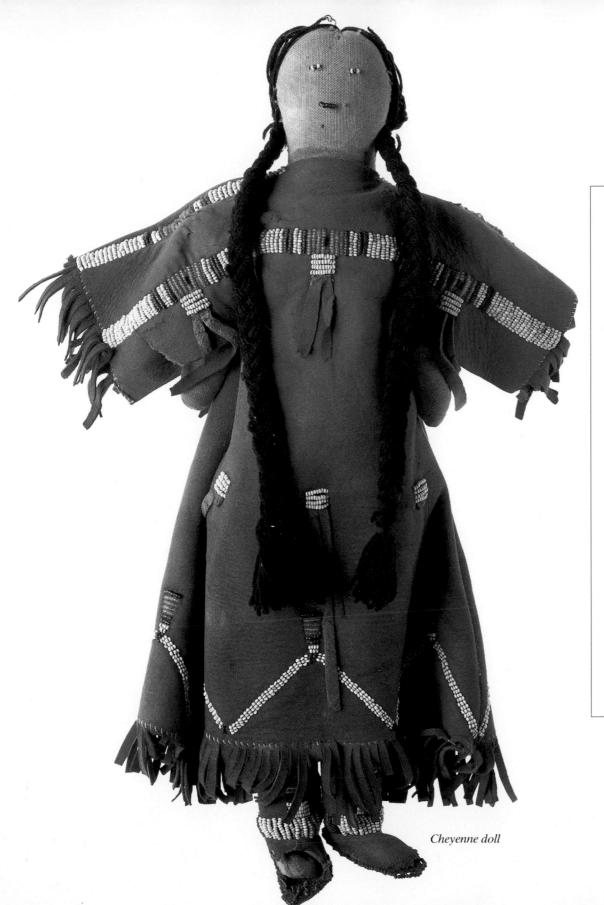

*Cheyenne doll*

A Cheyenne baby entered the world under the guidance and protection of sacred forces whose aid was invoked by ceremonies marking the milestones of childhood. During a girl's naming ceremony, conducted by a respected elderly woman who had been active in tribal ritual, the girl's ears were pierced and adorned with round abalone shell or bone earrings carved by her father. Afterwards the child's family hosted a feast and distributed gifts. In return, relatives showered the child with toys and dolls to help her along the path to womanhood.

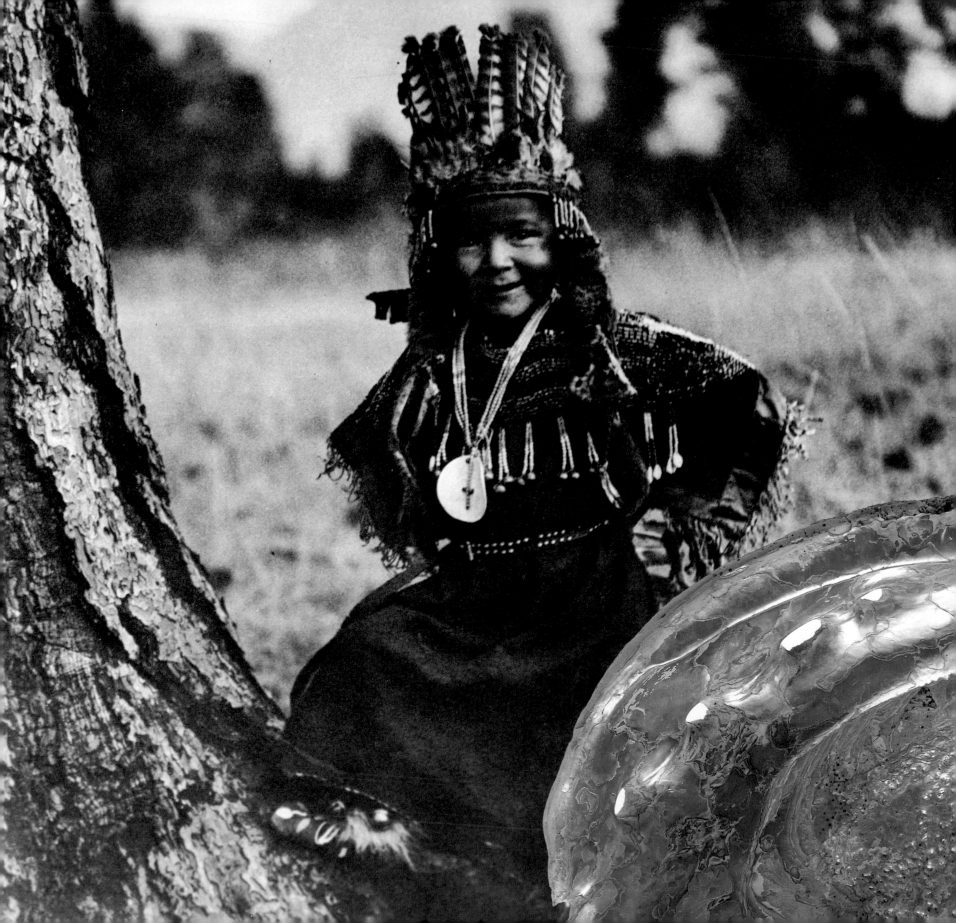

*Flathead girl*

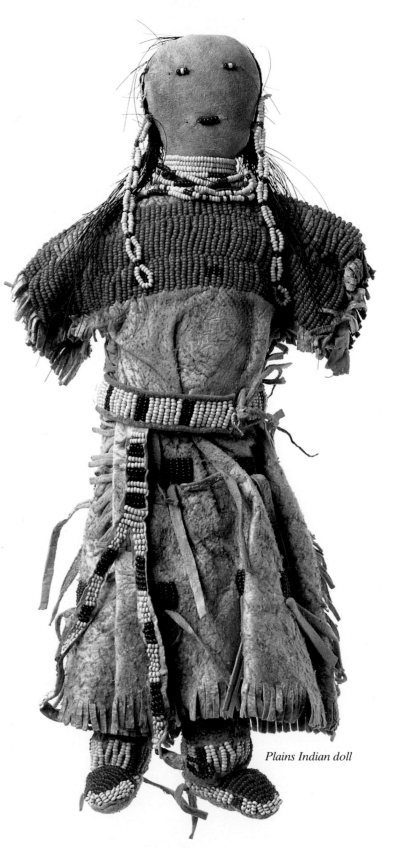

Plains Indian doll

A doll began life as a simple shape cut from tanned animal skin and stuffed with buffalo fur. If a child had long hair, she might attach some of her own to the doll's head. She would make the doll's dress from brain-tanned deerskin, then decorate it with glass beads sewn in patterns like those worn by women and girls for special occasions. During the late 1800s, Plains Indians sold beaded buckskin dolls to tourists. These souvenirs became collector's items or toys for non-Indian children. The Flathead girl on the opposite page wears a wool dress decorated with rows of beads, bead tassels, sea shells, and a necklace of abalone shell. The shells were probably acquired through trading with coastal tribes.

*Polished abalone shell*

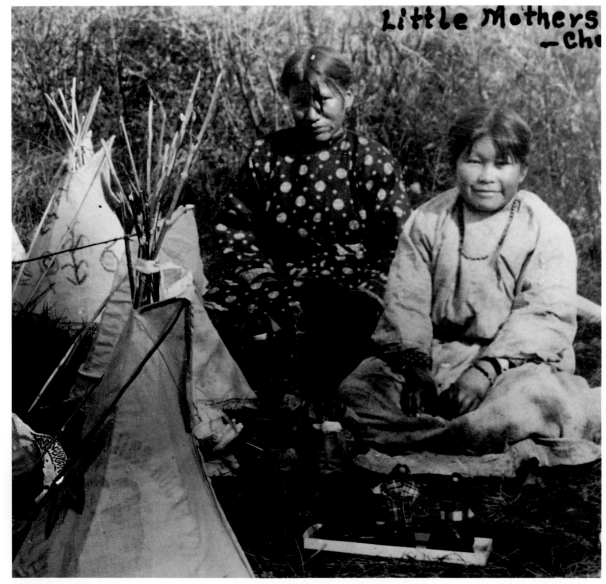
Little Mothers
—Che

*Cheyenne girls at play*

**D**oll dresses were patterned after adult clothing and although simplified in design, reflected the fashion trends of the time. Before manufactured cloth became available, dresses were made by folding deerskin in half, then cutting or sewing on the sides as needed. Sleeves, when included, were left open. Beginning around 1850, dolls sported brightly-colored dresses of trade wool or calico. Some were made without facial features, or with only eyes or a nose. It was left to the child to supply the doll with a personality. Grandmothers showered their granddaughters with dolls, miniature tipis, and even miniature domestic furnishings.

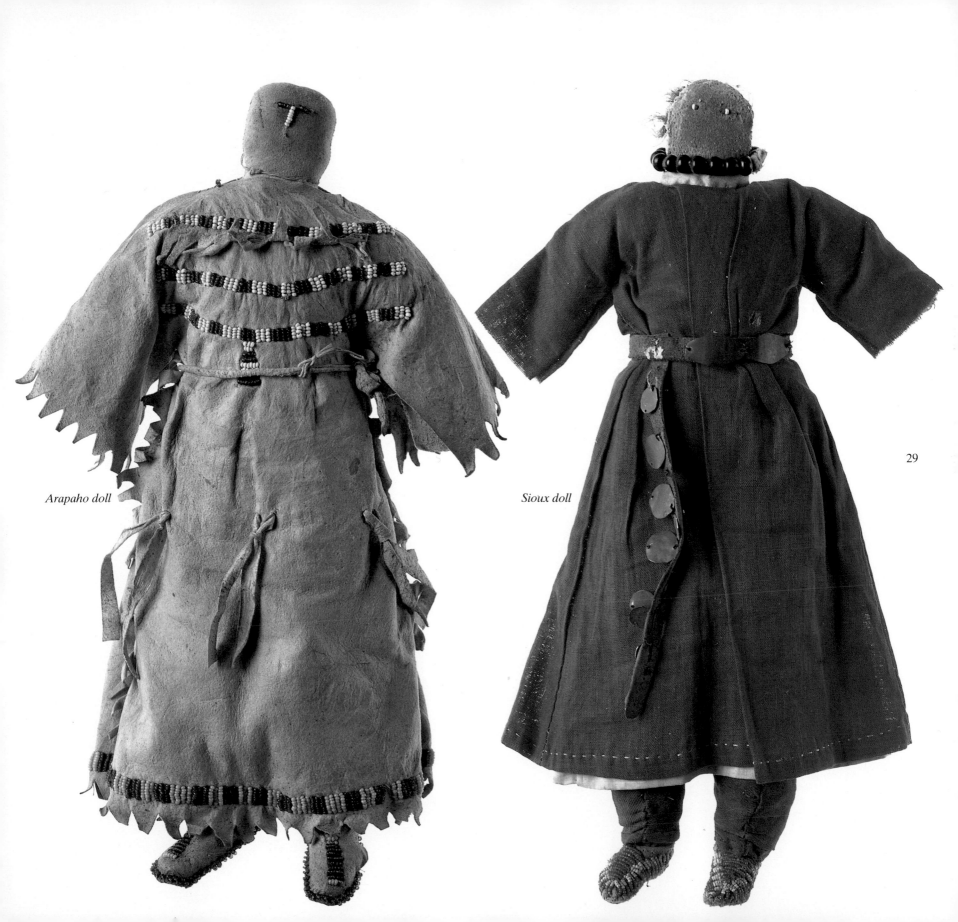

*Arapaho doll*

*Sioux doll*

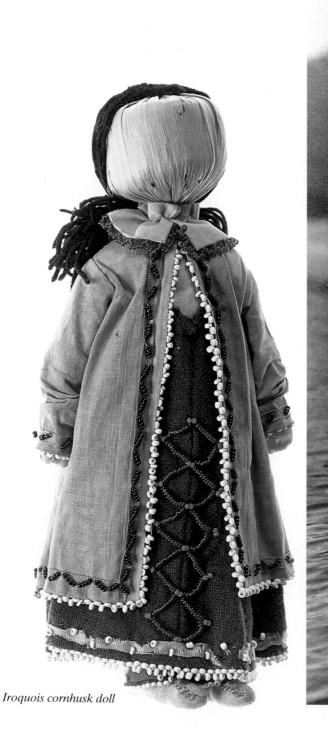

*Iroquois cornhusk doll*

30

Among the Iroquois and other tribes of the eastern woodland, corn reigned as the most important crop, providing food that could be stored through the winter. Its growing cycle anchored the ceremonial year. Even its dried leaves had value when made into ceremonial masks and cornhusk dolls. The dolls on these pages show the influence of European designs and materials, in the use glass beads and the cut of the dress and coat. Woodland children grew up with a knowledge of rivers and bark canoes, which together carried their families from one hunting ground to the next. When moving, everyone had jobs to do but most of the work fell to the women and girls. Although childhood was a happy time, the pleasures of life were inseparable from the hard chores of survival.

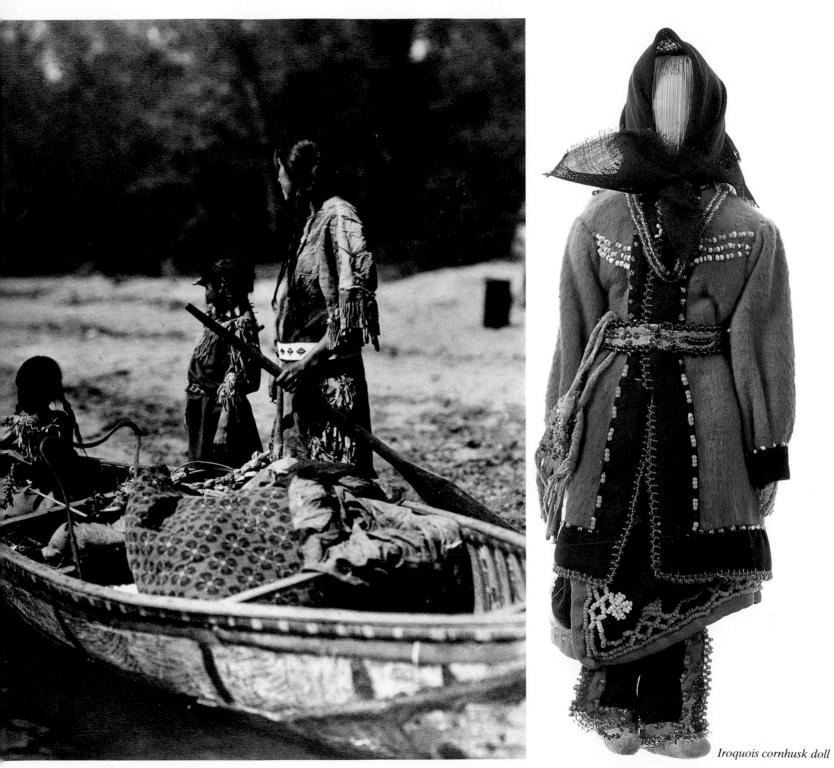

*Ojibwa woman and children*

*Iroquois cornhusk doll*

The first dolls made by the Sioux and other Plains tribes were simple figurines of clay or rawhide cutouts stuffed with buffalo hair or grass. Through time, as trade goods such as beads and fabric became available, clothing grew more complicated both for adults and dolls. Although Plains women were experts at making fine tanned buckskin dresses, they preferred the feel of cotton, which was also much easier to work with. The girl on the opposite page wears the latest fashions of the late nineteenth century.

*Sioux doll*

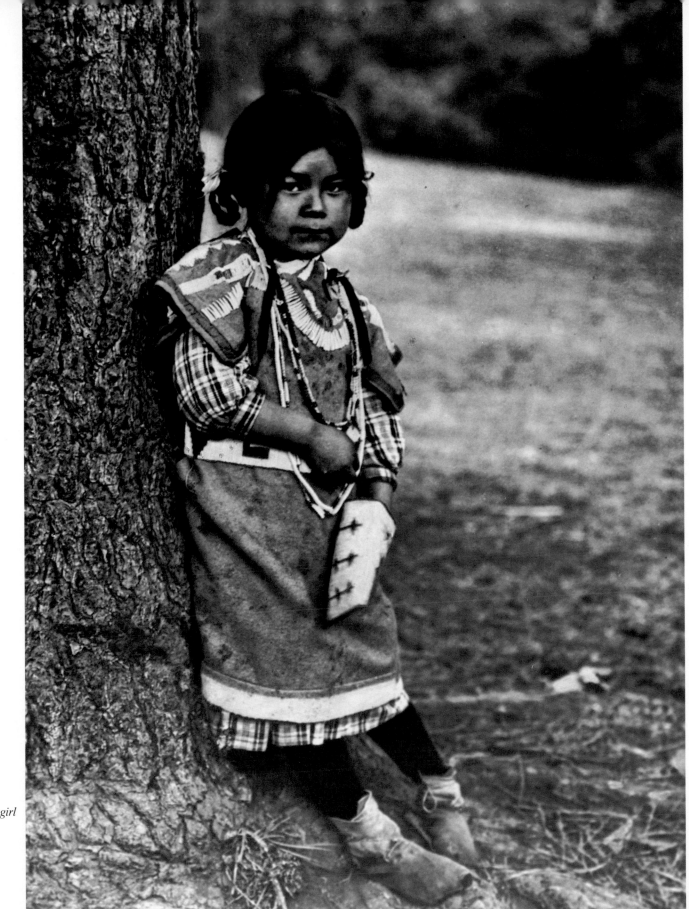

*Umatilla girl*

33

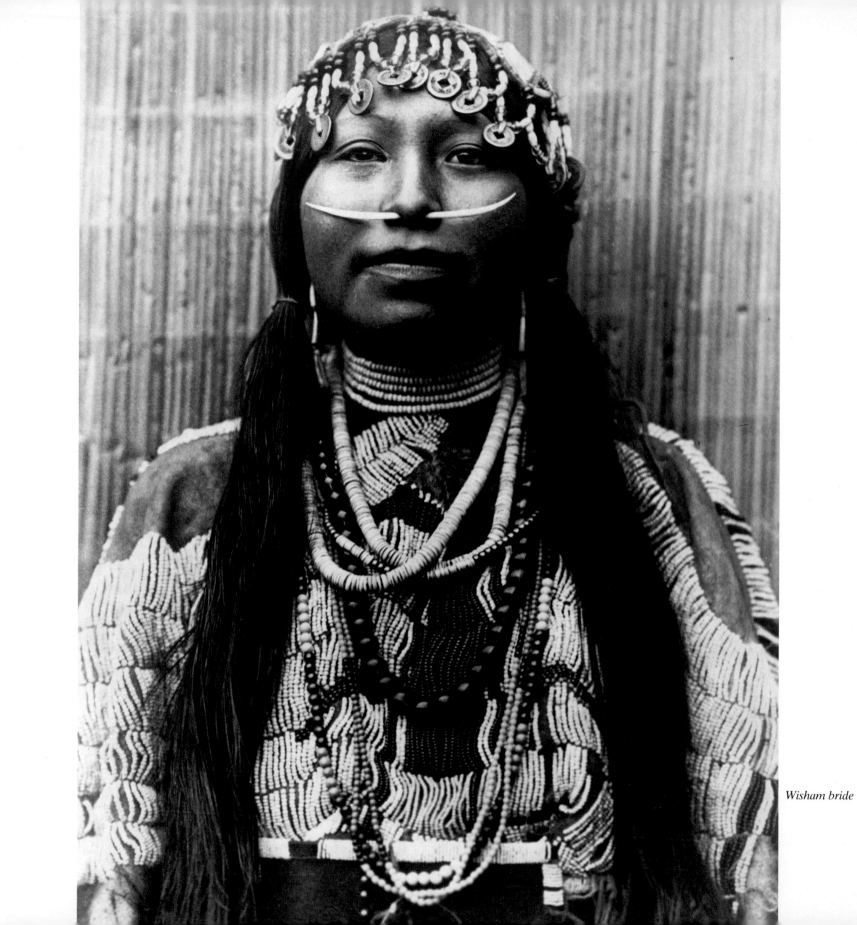

34

*Wisham bride*

*Arapaho doll*

**M**ost dolls were the product of elderly women who made them as gifts for their granddaughters. Sewn with painstaking attention to detail, dolls and their accouterments helped a girl learn her family's way of making household objects. As she grew older and made her first actual garment, a ceremony was held and the object proudly presented to an elderly relative or to some other respected individual. This important moment marked a girl's first step toward adult responsibilities. Sometime later, in honor of a girl's first menstrual period, another ceremony was held. At that time she gave up the things of children, and entered the world of adults. Soon she would marry and become a mother herself. Even so, many women kept one favorite doll throughout their lives.

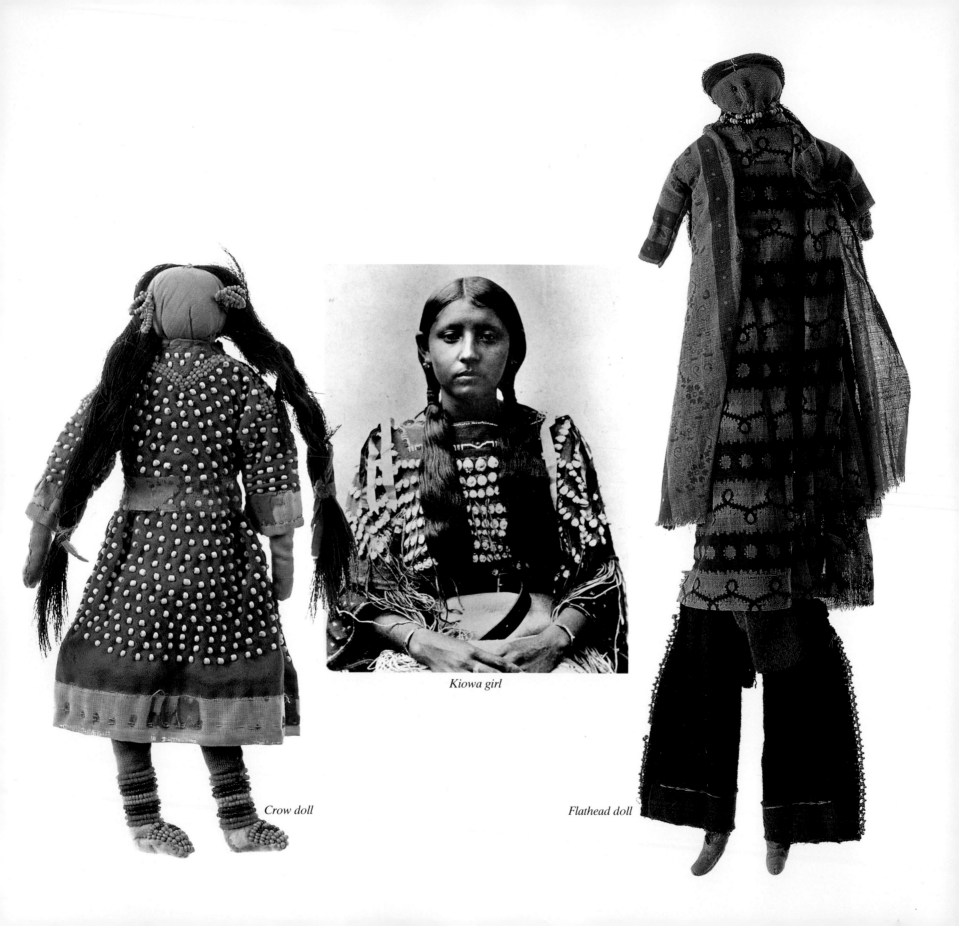

*Crow doll*

*Kiowa girl*

*Flathead doll*

*Sioux doll*

ach tribe had its own style of dress which was reflected in the dress of its dolls. For example, the white beads on the dress of the Crow doll (far left) represent elk teeth, which were used as clothing decorations by the tribe's women. The Kiowa girl's dress displays a different style of arranging elk incisors. The Flathead doll and the Sioux doll at far right are decked out in the best of Plains Indian men's ceremonial regalia. The doll directly to the left shows the Sioux preference for horizontal beaded bands across the chest.

37

*Sioux doll*

*Our first mother is the earth, from which comes all life. Our*
*second mother is the woman who gave birth to us.*
*And, for native peoples all across North America, there was*
*(and still is in many places) a third mother, the*
*cradleboard. Babies felt secure and protected in its warm*
*embrace, while mothers were free to do their work.*
*A cradleboard could be propped up near the mother; hung*
*from the high cantle of an Indian saddle; or hung*
*from a tree branch where it would swing like a hammock.*
*In the Great Lakes region, the Chippewa lined their*
*cradleboards with soft, absorbent fibers like dried moss or*
*rabbit fur, then laced their babies almost naked into*
*the warm nest.*

# OUR THIRD MOTHER

A CHIPPEWA TALE

By the time Floats Away Laughing
became a grandmother, she was already
a favorite storyteller among the Chip-
pewa children who lived on the north
shore of Lake Superior. "Tell us the
story of the sky canoe," they would say.
"Or the bear that went to the moon!"

But her favorite story was about
the time her mother left her in the
canoe. The family was on a summer
canoe journey—her mother, her father, two
older brothers, and herself—a six-month-old in

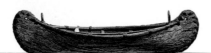

a cradleboard. It was a nice way for a baby to travel, propped up in the bow of the canoe where she could watch her parents paddle. The cradleboard also kept her from crawling around in the canoe getting in the way and maybe falling out.

The northern lake country was as much water as land. By following ancient water trails through interconnected lakes and rivers, a family could travel in almost any direction they chose. Their only obstacles were occasional rapids or points of land separating lakes, where they would stop to portage. Some days there would be no portages at all. Other days there might be fifteen or twenty.

It happened on a day with many portages. Whenever she got to this part of the story Floats Away Laughing would say something about her mother's absent-mindedness. "I have told you she was easily distracted," she would say, as if this could explain what came next. Certainly it was a complicated business keeping track of pack baskets, paddles, pots, loose items and three children, especially with clouds of mosquitoes biting. It didn't help to have her husband disappear with his bow, as he often did at a portage, in the hopes of bagging a grouse. He always returned to carry the canoe and the one large pack but it was her job to unload and start down the trail. Because she carried the cradleboard on top of her load, she a habit of leaving it and the baby propped up in the canoe until the last moment. Add to that the tendency of an unloaded canoe to float higher in the water, and perhaps it is possible to understand what happened next. At any rate, Floats Away Laughing's mother, having carried a basket up the steep bank, turned to see the canoe, with the cradleboard still in its bow, drifting into the teeth of the rapids.

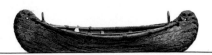

What went through her mind? There was nothing she could do but watch in horror and yell for her husband. He tore off down the portage trail, leaping boulders and crashing through the birch thickets, prepared to plunge into the river below the rapids in the hope of saving his daughter. But he was too late. The light canoe was far ahead of him. It had run the rapids as if charmed, as if a benign spirit had intervened, sending it through the water high and fast. Then the current took it, and the last he saw, it was drifting lazily downstream toward a big lake.

"Were you frightened?" the children always asked at this point in the story, and Floats Away Laughing would answer, "No. I was wrapped in my Third Mother. I think I was asleep."If so, it was a good long sleep. It took until late that evening for her father to locate another canoe. With the help of two other men he came pad-dling into the lake, weighed down by fear. The lake was filled with islands on which a boat could run aground, and they searched for several hours before finding the lost canoe. The wind had pushed it into the wild rice as if trying to hide it.

And how was the baby? She was being entertained. Several large iridescent dragonflies had chosen the hoop of the cradleboard for a perch. Like flycatchers, they shot into the air and caught mosquitoes, then returned and rubbed their huge luminous eyes. They were living jewels, spinning and twirling in the evening air. The baby was watching them, clapping her hands and laughing. For a while after that people jokingly called the mother "Forgets Her Baby"; for the rest of her life the baby was called "Floats Away Laughing."

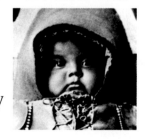

T heir "third mother" was a source of comfort to infants. Wrapped in soft fur or doeskin, then padded in the appropriate places with dried moss or shredded bark, babies were laced into the board during the day and taken out for the night. As a baby grew, he learned to free his arms and unlace himself from the cradle, yet eventually the child would crawl back to the board and demand to be laced in firmly. A girl could practice lacing the toy cradleboard and rocking her doll to sleep in it.

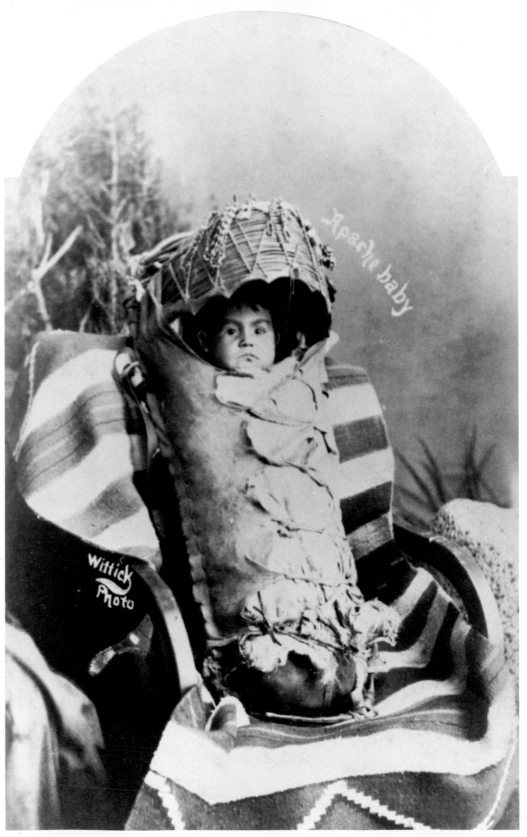

*Apache baby in cradleboard*

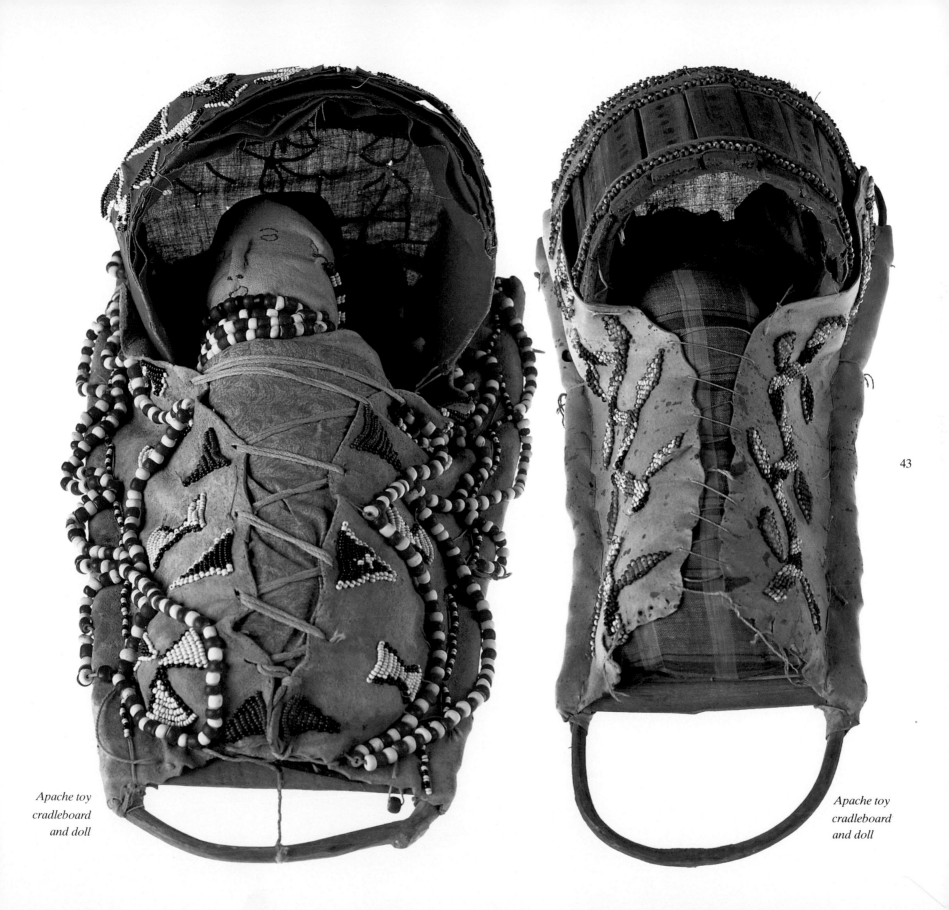

*Apache toy
cradleboard
and doll*

43

*Apache toy
cradleboard
and doll*

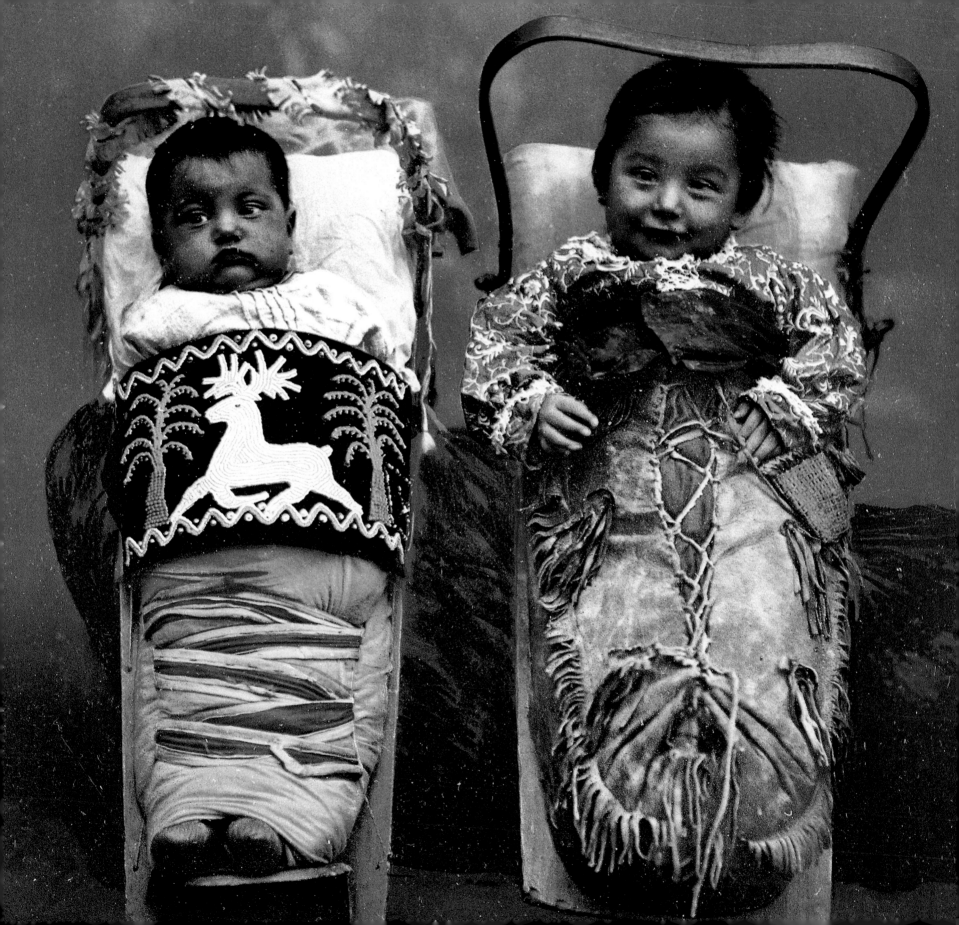

**C**radleboards were ingenious solutions to the problems of child care. Holding a baby in its secure embrace, a cradleboard could be carried like a backpack, hung from a saddle, or propped up near a mother while she worked. Among the

*Ojibwa toy cradleboard and European doll*

Algonquian-speaking tribes of the Great Lakes region, cradleboards were rectangular planks with U-shaped foot boards and wooden arches over the head. Some were made from living trees to symbolize the young lives they nurtured.

*Ojibwa babies in cradleboards*

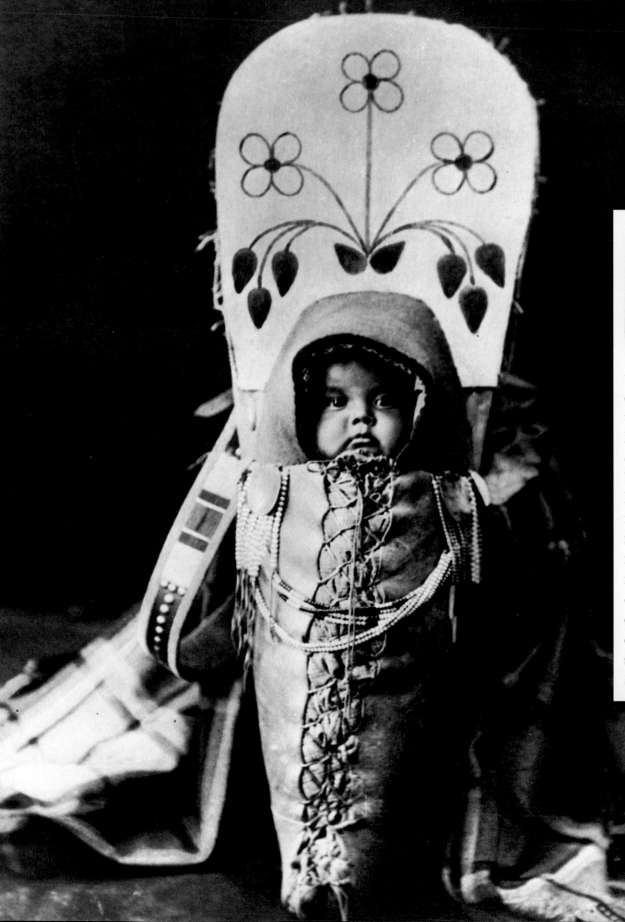

**U**-shaped hoops over the head and a tapered design characterized cradleboards of the Great Basin and Columbia Plateau tribes. Full-size cradleboards like this beautifully beaded one holding a Nez Perce baby brought their makers high esteem. They were made not by the expectant mother but by a close female relative, or by a woman who excelled in the craft. In appreciation of her effort, the craftswoman would receive something of value—perhaps a horse or trade goods.

*Nez Perce baby in cradleboard*

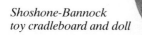

*Shoshone-Bannock
toy cradleboard and doll*

*Apache toy cradleboard
and doll*

47

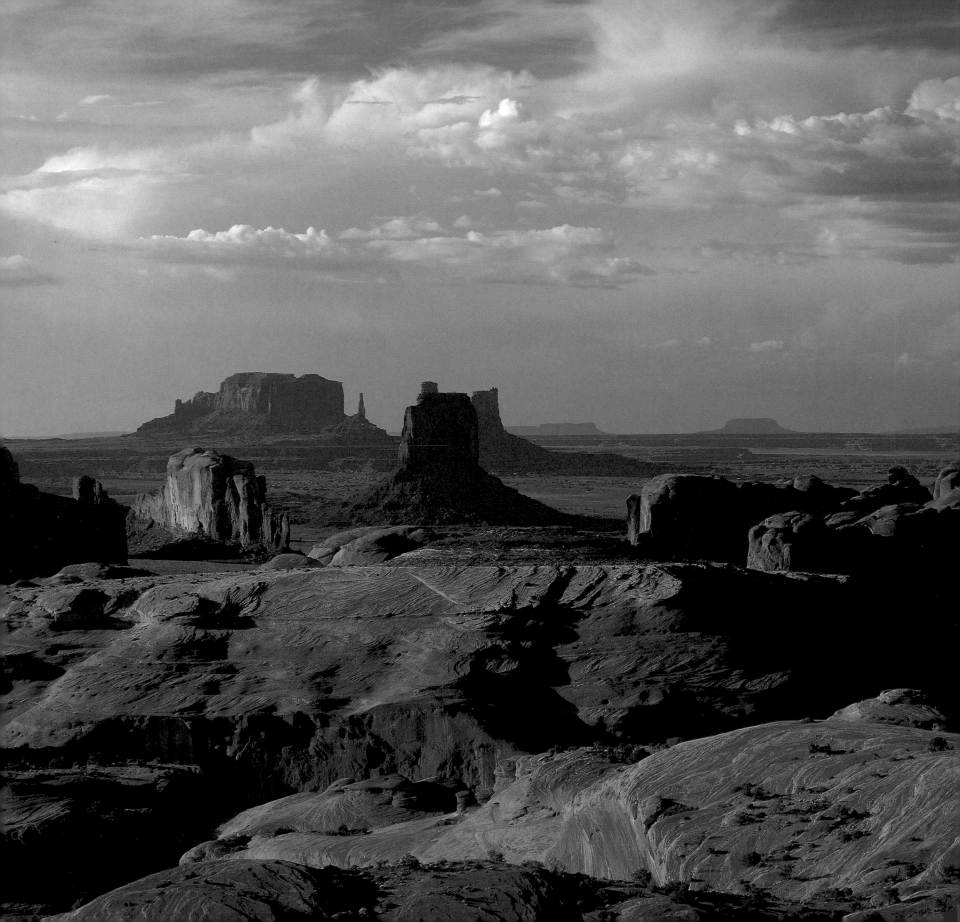

*The Hopi have lived for centuries on a series of high mesas in northeast Arizona. Theirs is a landscape filled with spiritual meaning, a world in which Kachinas play a central role. Kachinas are spirits that serve as intermediaries between the gods and human beings. For six months every year, beginning with the winter solstice, Kachina spirits live among the Hopi, appearing at religious ceremonies in the form of masked dancers. By ancient tradition, children are given dolls carved in the form of Kachinas to help them recognize and remember the guardian spirits.*

# WICKVAYA'S KACHINA

## A HOPI TALE

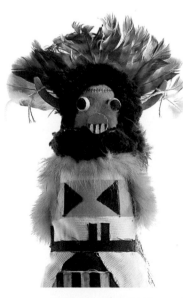

In the time of shortening days, when ice crystals made lace of the stream bed and cottonwood leaves turned gold and dropped like Spanish coins on the red sand, Wickvaya went looking for a cottonwood root.

He had put it off too long. In only three months six-year-old Kaeuhamana, his special granddaughter, would be initiated into the Kachina Society. In the autumn of his life, she repre-

sented the spring of his family, and he felt an unusual affection for her.

Now he needed a cottonwood root from which to carve the Kachina doll that would be given to her during the Powamu initiation ceremony. The doll would help teach her about the Kachina spirits, the guardians and helpers of the Hopi people, symbols of the unseen world.

There were many different Kachinas, each with unique powers. Some were named for animals—Owl, Eagle, White Buffalo, Badger; others had names like Crow Mother, Corn Maiden, Throwing-Stick Man, or Hopi names that have no English equivalent, like Eototo, the chief of all Kachinas. Some brought rain. Others helped the crops grow or defended the people in war. Some were terrifying in their power, but many were kind, and usually came bearing gifts. Each of them in one way or another served a purpose—even the ogres, or monster Kachinas, who were capable of doing all sorts of awful things. It was important for children to recognize the Kachina spirits, and this was the intention behind Kachina dolls.

Wickvaya had not decided yet which one to carve, but he thought it should be one of the comforting, friendly Kachinas. The Powamu initiation was scary enough, especially the night when, after many days of preparation, the children were led into the kiva. Boys were lined up on one side of the underground ceremonial chamber and girls on the other. An elder of the tribe sang a long tale of tribal history, followed by secret initiation rites. But to every child, the most memorable part was the arrival of the Hu' whippers—the ogres. These were fearsome

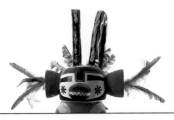

Kachinas with curving horns, bulging eyes, and sharp teeth. As they came down the ladder into the kiva, they thrashed the air with their yucca whips. Then one by one, the children were presented to the ogres, who struck them with the sharp-edged yucca. Their message: Obey the elders. Keep to the way of the people.

Wickvaya knew that this was a frightening moment, but an important one. Children needed to take the rules seriously. And although the whipping was more scary than painful, it made a lifelong impression.

There would be happier ceremonies to come, including the following evening, when the Kachinas would dance without their masks. In this way, all the new initiates would see that Kachina dancers were merely men of their village impersonating the spirits. Wickvaya would be one of the dancers, and he would present Kaeuhamana with a new Kachina doll. He wanted it to be a pleasant memory for her, not a fearful one.

He found what he was looking for at a bend in the river. Summer flood waters had undercut a great dead cottonwood, exposing long, sinuous roots. Dried and weathered by the desert air, the roots gleamed white. With his knife he began cutting a section, and as he worked, he noticed several strands of dried corn silk wrapped around the root. "They must have been carried by the wind from a nearby farm field," he thought. Seeing them made him think of the Corn Maiden. Wickvaya smiled. That's what he would carve for his granddaughter.

51

The Hopi Kachinas are spirit beings who the
Hopi believe bring benefits to the world. During
the six months of each year when they reside
among the Hopi, Kachinas are impersonated at
ceremonials by male dancers. This is not make-
believe. A Hopi man who dresses in appropriate
costume and places upon his head the mask of a

Kachina is believed to receive the spirit of that
Kachina. Kachina dolls, however, like this one
representing Pang, the mountain sheep Kachina,
have no intrinsic power. They are teaching aids,
carved to instruct children about the real spirits, of
which there are more than three hundred.

*Hopi Kachina doll*

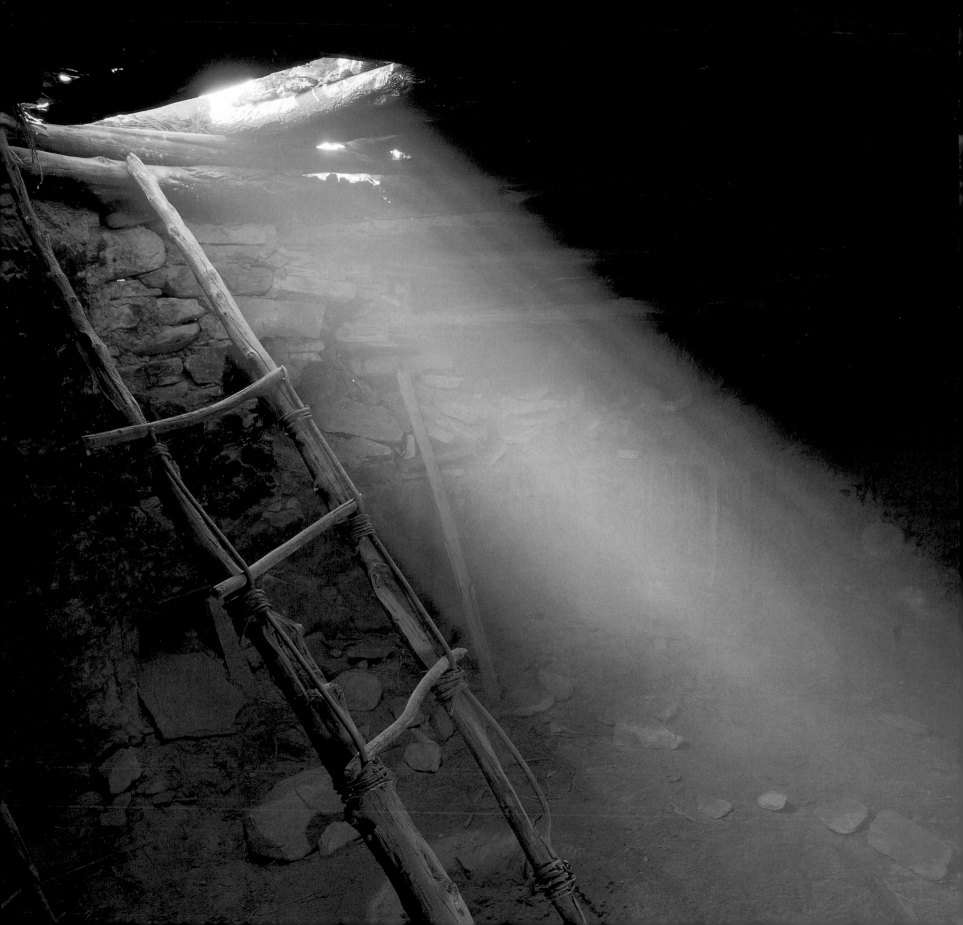

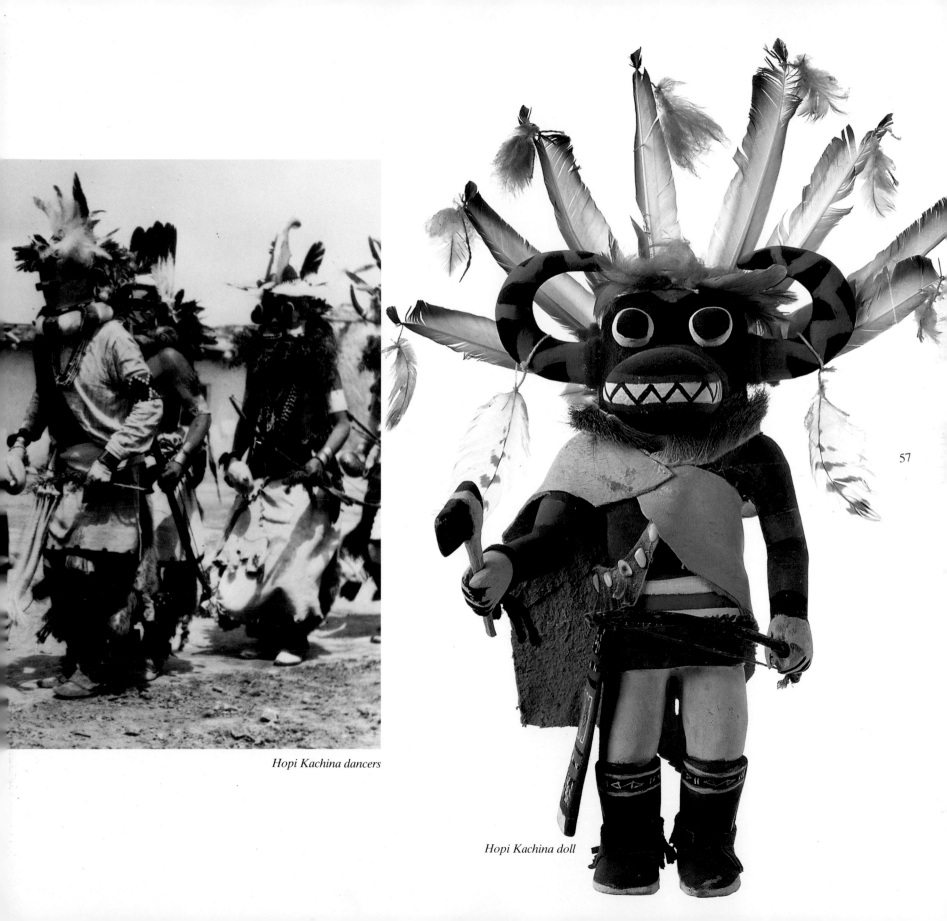

*Hopi Kachina dancers*

57

*Hopi Kachina doll*

58

**H**opi children learn about Kachinas through ceremonial dances and carved dolls. If they are well-behaved, costumed Kachina impersonators will befriend them, often bringing gifts. But they were also warned about—and threatened by—frightful Kachinas like the ogre doll shown here. In this way they learn about good and evil, and how to tell right from wrong. Opposite: Each Pueblo village has a plaza at its heart which is used for ceremonial dances. For a child the sight of human dancers, dwarfed by huge and powerful presences like these Hemis Kachinas, leaves an indelible impression.

*Hopi Kachina doll*

*Pueblo Kachina dancers*

Southwest of the Hopi mesas live the Zuni people, who every year in December hold their house-blessing ceremony during which Shalako spirits, standing as much as ten feet tall, arrive in the cold moonlight. The spirits dance all night, celebrating the timeless connection between living Zuni, their ancestors, and their gods. Similar beings first visited the Hopi mesas around 1850, when a group of four made their appearance. Called Sio Shalako, and represented by the doll on this page, they are Hopi versions of the same spirits and have many of the same attributes. The doll on the far right is an ogre called Nata-aska. A frightening character, supposedly able to swallow a child whole, he accompanies Ogre Woman on her trip to collect food from children. The photograph shows a Kachina dance at a Hopi village.

*Zuni Kachina doll*

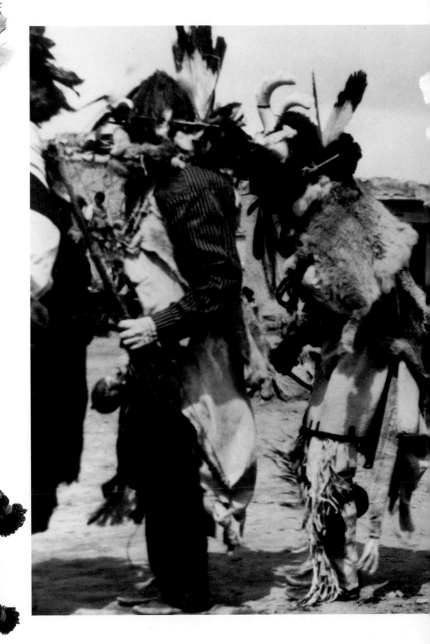

**K**achinas have
been helping the Pueblo
people for hundreds of
years, going back at least
to the time of Anasazi, the
ancient ones, who built the
first kivas, or ceremonial
chambers, like the one
shown opposite. The kiva
represents worlds past and
present; in the floor is a
small hole, or *sipapu,* to
symbolize the place where
humans, led by Kachinas,
first emerged into the pre-
sent world. This Kachina

doll represents Soyoko, or
Ogre Woman, an ogre
Kachina who appears dur-
ing the Powamu cere-
mony. She visits homes of
children, says she is hun-
gry, and tells the boys to
hunt mice and rats for her
to eat. If they fail, she says,
she will eat them instead.
The same threat applies to
girls, although they are
ordered to supply piki
bread made from
cornmeal.

55

*Hopi Kachina doll*

*Anasazi kiva*

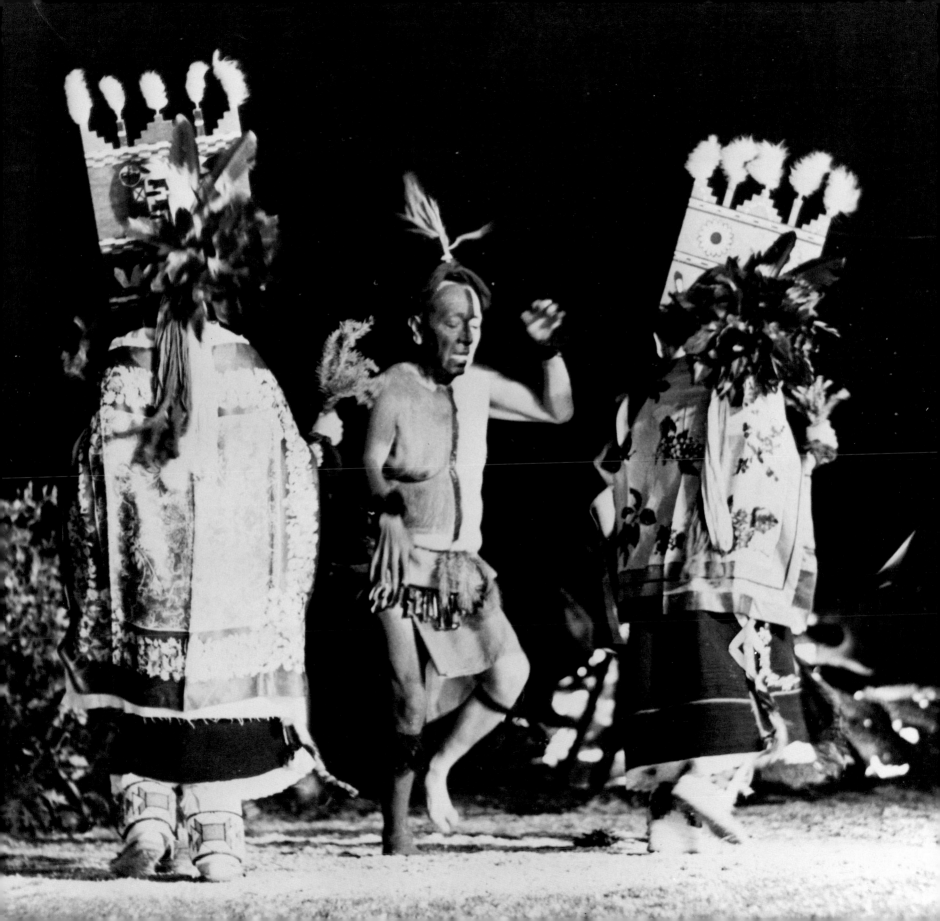

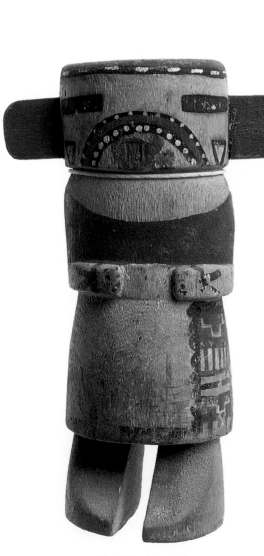

60

*Hopi Kachina doll*

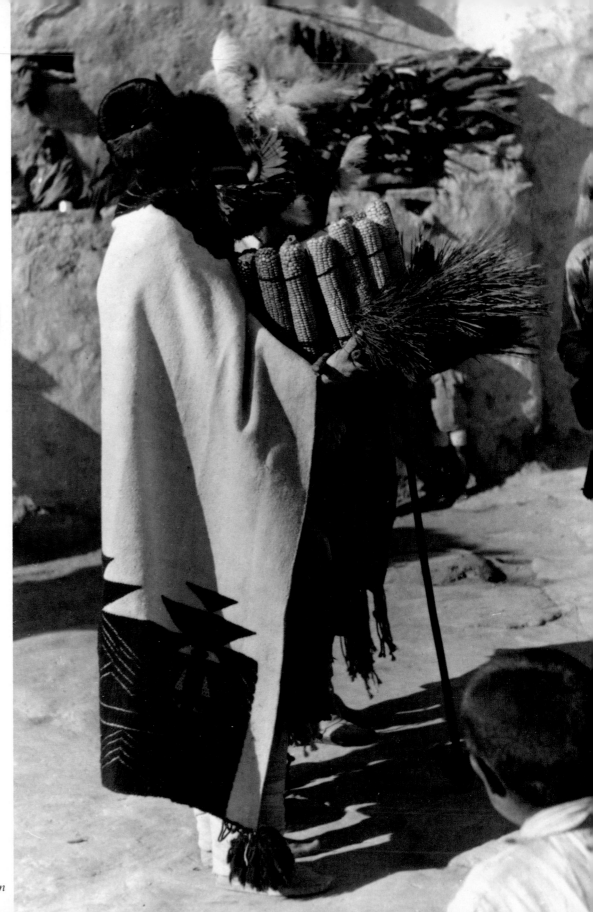

*Hopi Corn Maiden*

*Hopi Kachina doll*

**H**opi children are raised to believe that Kachinas carve their own dolls at their home in the spirit world. Old-style dolls like the Rainbow Kachina (far left) were not meant to stand on their own. Instead, the doll was hung by a string around its neck on the walls or rafters where it would be seen by the household's children and their playmates. The more modern Mudhead doll on this page represents a kind of ogre who joins other Kachinas at some dances, although sometimes a group of Mudheads will conduct a dance of their own. The photo shows a Hopi girl with a squash-blossom hairstyle carrying a basket tray filled with corn—an important item in many Hopi ceremonies.

61

*The people of the Arctic—Eskimo, Inuit, Inupiaq, Yup'ik, and others—make their way in the earth's most unforgiving and extreme natural environment. Modern developments have ended the fear of famine, but in the old days life revolved around hunting, which by its unpredictable nature brought times of plenty and times of famine. Survival depended on the seasonal migrations of caribou and sea mammals, and these in turn were controlled by spiritual forces. If the seals abandoned the people, it meant that Sedna, the female spirit who gave rise to all sea mammals, was offended. Success in hunting always required spiritual merit, particularly when times were hard.*

# GREAT-GRANDFATHER'S HUNT

## AN INUIT TALE

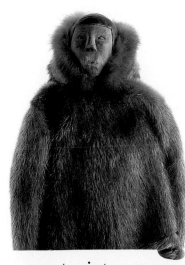

Whenever her grandson brought out the toy sled, Katalak remembered the winter when everyone went hungry, and some of the old people walked out onto the ice alone, to die so they would not burden their families. It was the worst winter anyone had ever known—not for the cold, the wind, or the lack of sun, for those were normal aspects of any winter. What set

that terrible one apart was that the seals went away.

The holy men said the people had broken taboo. They sang songs to call the seals back, but none came. Hunters went out into the Arctic twilight and sat for days at a time above holes they had cut in the ice but no seals came. The people dispersed, moving in family groups to hunting areas of their own choosing. Still there were no seals.

Katalak had never known her father to fail in hunting. A religious man, he paid strict attention to living a life of spiritual balance. He had always enjoyed good fortune. Yet that winter, nothing helped. It seemed that except for hungry people, all the earth's creatures had vanished. The family meat cache was long empty. Even the dogs were dead.

She could not say what drove her father out that last time. Was it despair over his failure and his family's hunger? Or was he spending his last strength, having decided it was better to die hunting than to fade away in the snow house?

As he told it in later years, he had walked alone through the unending twilight until he was so tired that he lay on the ice and slept. When he woke, he heard dogs running, and realized that a sled was coming toward him— an empty sled, as if some unfortunate hunter had fallen from it and the dogs had kept running. "I must catch them," he thought. Hiding behind an upturned block of ice, he waited until they came close, and then leaped out to grab the rear of the sled.

The dogs ran, and he could find no strength to stop them. They ran a long distance. As he put it, "They ran to the moon and back." They ran and ran until they reached the frozen edge of the sea, where ice floes rolled in the gentle swell, and water yawned black in the openings between the floes. Here the dogs stopped, and here he saw the walrus.

It was a huge animal, a solitary male stretched out like a black mountain, and an

amazing sight, for this was not the season of walrus. It seemed to be asleep. How had it failed to hear him coming? Why did it not fight as he drove the ivory blade of his harpoon down, down through the inch-thick hide, past the shoulder and into the heart?

Perhaps, as her father claimed for the rest of his life, it was a spirit walrus come to give its meat to the people; perhaps the dogs too were spirit dogs. Katalak herself believed this because after he killed the walrus, the dogs and the sled were nowhere to be seen. At first this filled her father with fear. He now had plenty of meat, but how could he walk so many miles back to his family? Nevertheless, he ate what his shrunken stomach could hold, filled his parka with the best pieces remaining, and set off on foot.

To his great surprise, he had only a short way to go. Perhaps the dogs had run in a great circle, because just on the other side of a low ridge he found the snow house. Katalak still remembered the moment when her father burst in, yelling in triumph and pulling big chunks of meat from his parka. Later the family went out together and dragged back the rest of the walrus. At first they ate it raw. Then they cooked it in the flame of its burning fat. They saved its sinews for sewing. Its skin, its bones, everything was useful. To commemorate his story, her father carved a sled, a team of dogs, a hunter, and a walrus from one of the beast's tusks.

Katalak never forgot the story, and never let her grandson play with the tiny ivory sled without telling him about his great-grand-father's most illustrious hunt.

65

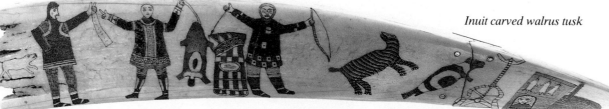

*Inuit carved walrus tusk*

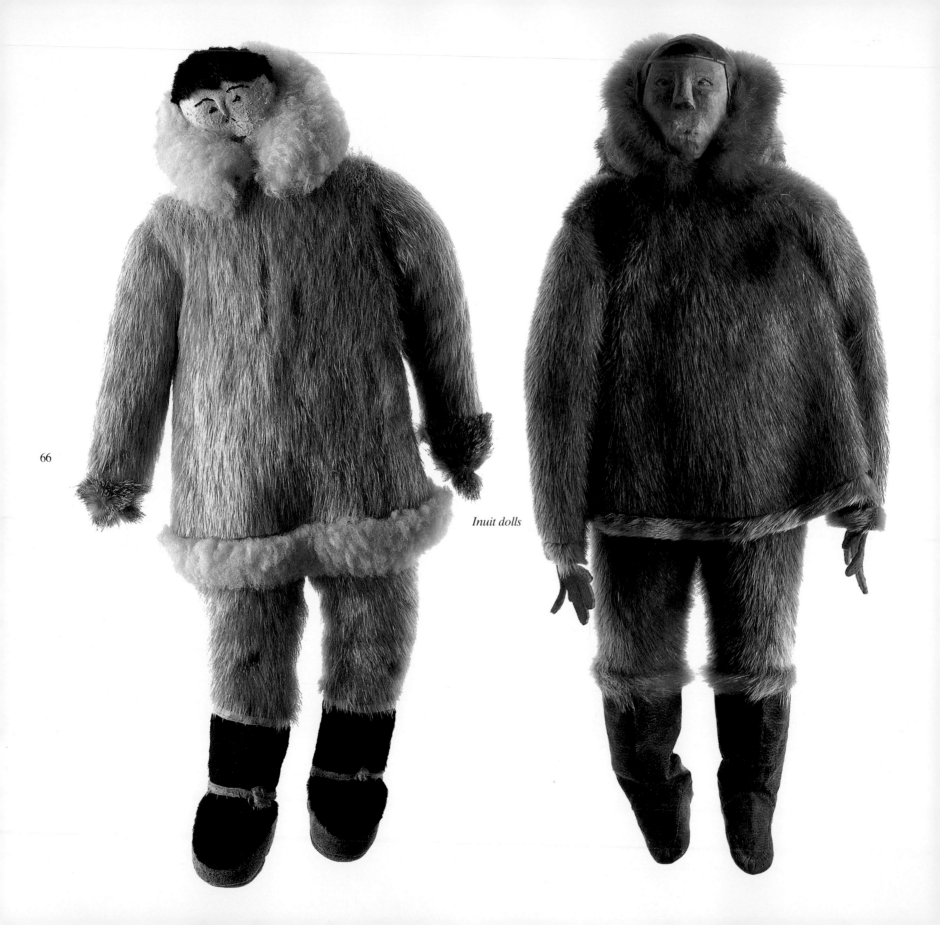

66

*Inuit dolls*

**A**s Plains Indians relied on buffalo, so Arctic people depended on seals for meat, sinew, bone, and skin. The dolls wear the traditional sealskin hunting suits of the Inuit (formerly known as Eskimos). Essential to survival, hunting was the most important task of any father. To help his sons learn the right skills and attitudes, a father would provide them with miniature sleds, harpoons, bows, and arrows. Young hunters also had spiritual lessons to learn. After a successful hunt the dead seal would be laid out on its back inside the snow house. The woman of the house would pour water into the animal's mouth to thank its spirit and to encourage it to return another time with another physical body.

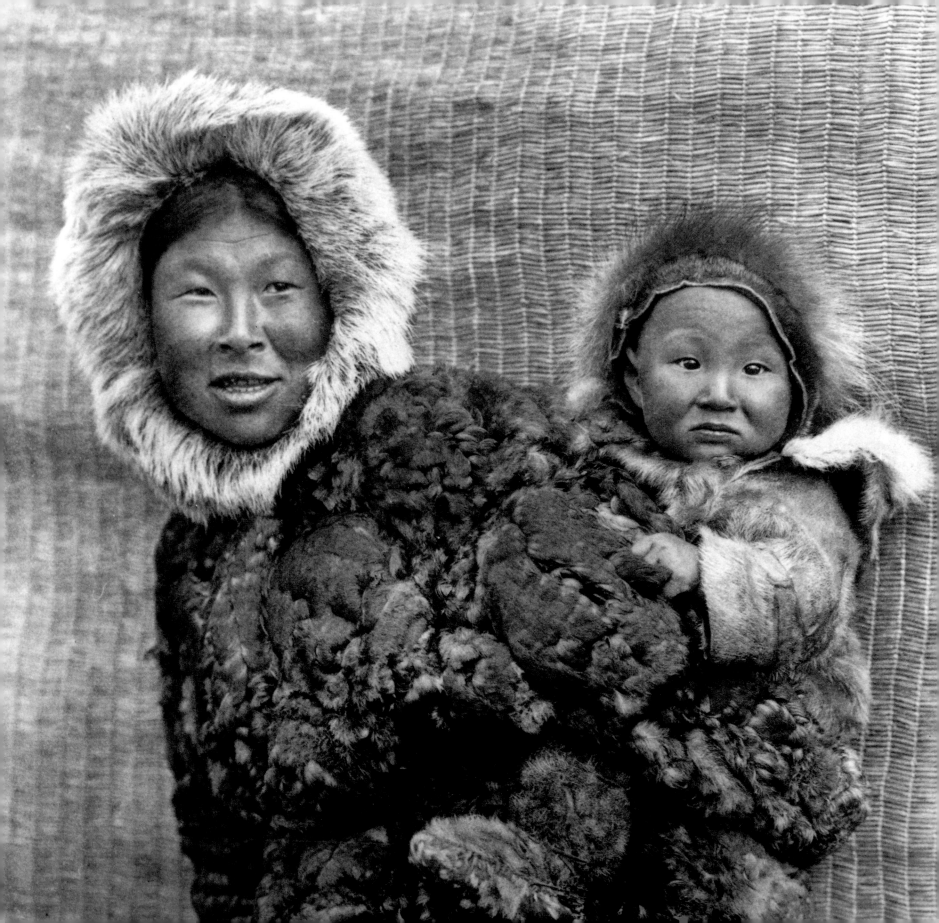

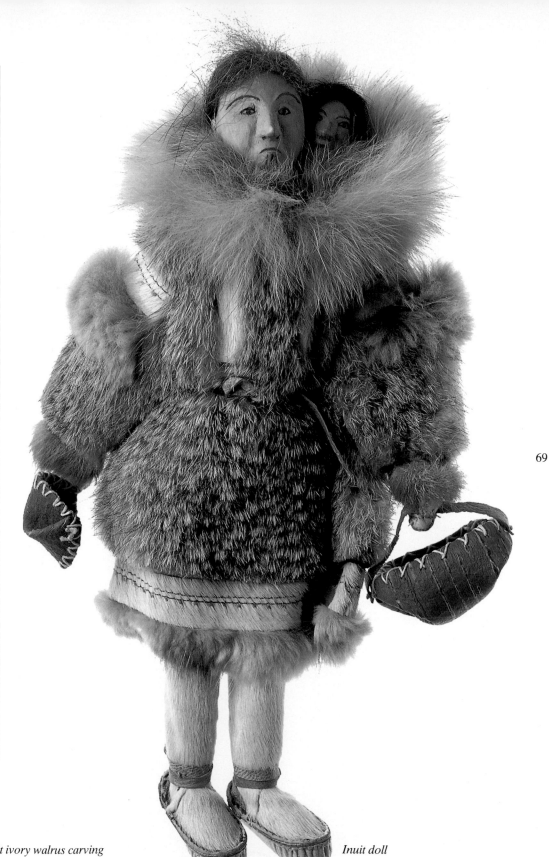

Inuit childbirth was surrounded by taboos. An expectant mother was not permitted to remain in her family's igloo. Instead she was isolated in a small igloo where she would deliver her baby alone. After birth, she would remain apart for another month, during which time she was forbidden to eat any meat not killed by her husband. Despite such taboos, Inuit families lived most of their lives in close intimacy. Parents felt that, because adult life would be hard, childhood should be a time of joy and freedom. On the opposite page, a mother and toddler are tucked snugly in warm furs. Traditionally, an infant rode against its mother's back beneath her parka, sharing her warmth. Two faces peered out from a soft fur ruff, as with this doll and her child. The doll also carries a gathering basket.

*Nunivak woman and child*

*Inuit ivory walrus carving*

*Inuit doll*

69

**D**uring the short, brilliant summer, when ice temporarily lost its hold on the land, Inuit hunters moved south in search of caribou on the treeless tundra. For most of the year, however, they relied on sea animals—fish, seals, walrus, and others. Like igloos, dog sleds, kayaks, and other items of classic Arctic cultures, the image of a man poised motionless above a hole in the ice is a stereotype that fails to reflect the diversity of northern societies. Yet the image contains truth, and speaks of the enormous patience and stamina required of those who would survive in such an environment.

*Inuit soapstone carving*

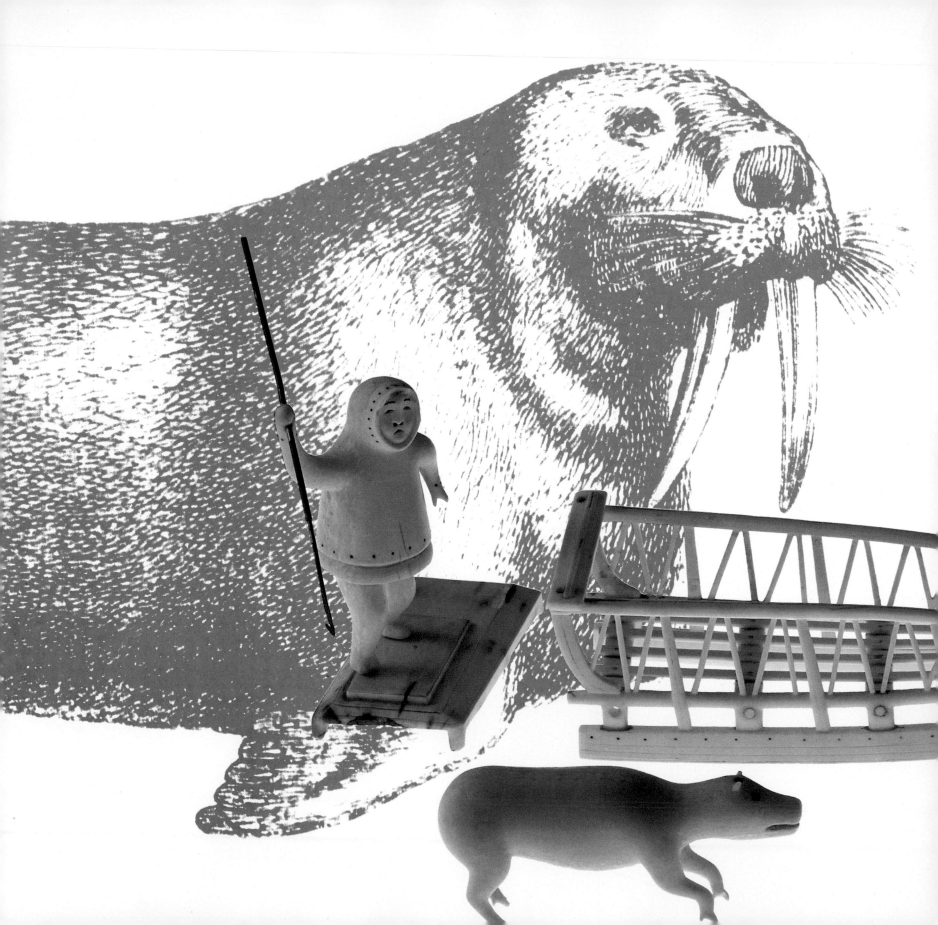

nuit carvers were blessed
with a variety of materials: drift-
wood, soapstone, bone, antler,
teeth from bears and whales,
and, in Alaska, the heavy tusks
of prehistoric mammoths. Yet
more than anything else they
preferred the curved ivory tusks
of the walrus. Like other Native
Americans, the Inuit had no
distinct concept of art, nor any
word for it in their native lan-
guage. Art was inseparable
from daily life, and whether
making the tools of his trade or
miniatures like this ivory hunt-
ing set, the carver approached
his work with the same sense of
design and utility.

73

*Inuit ivory carving*

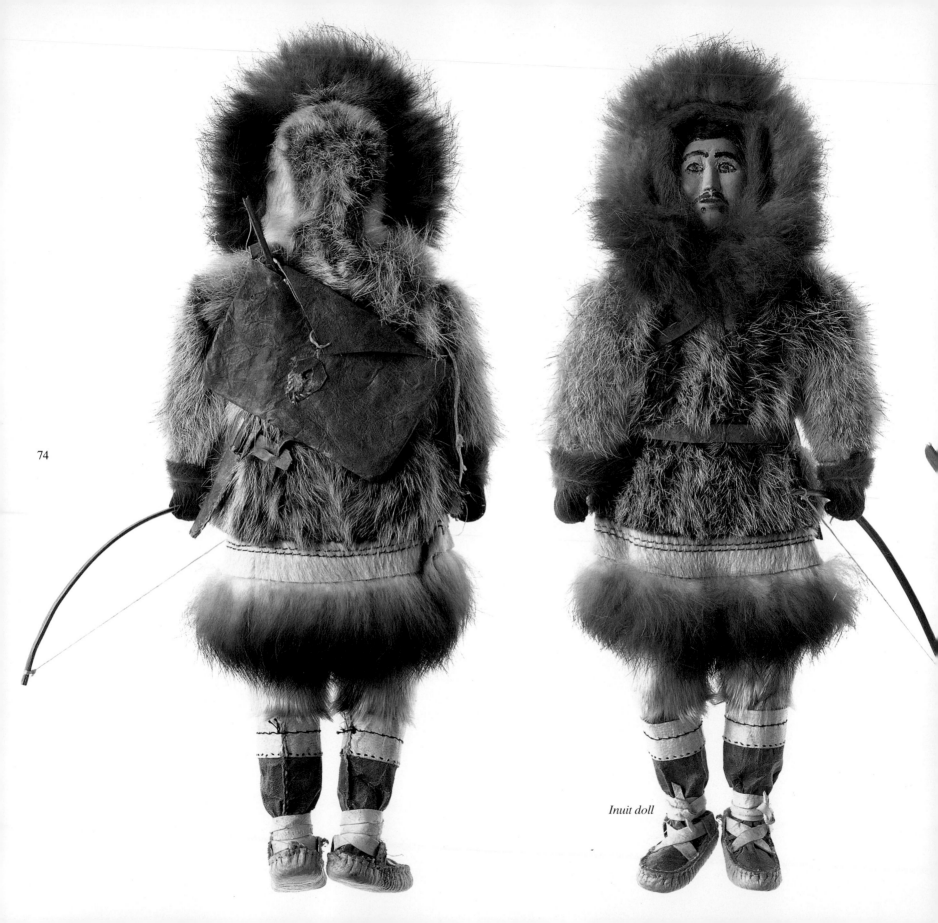

74

*Inuit doll*

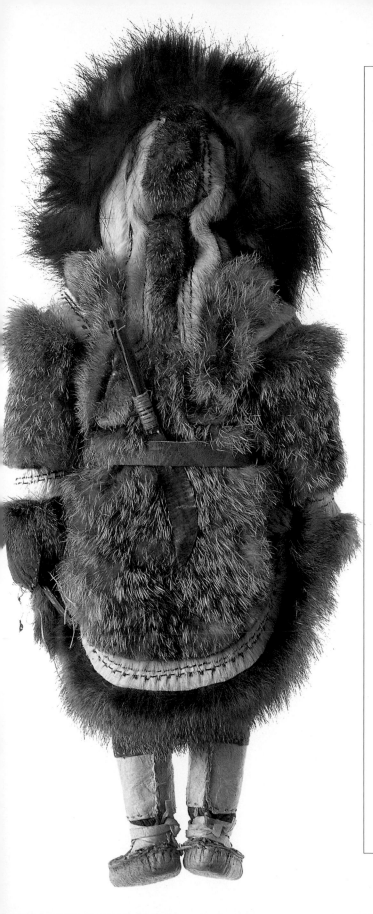

During childhood an Inuit girl stayed close to her mother. From an early age she helped care for the elderly, hauled her baby brother or sister around on her back, and sewed clothing similar to what these dolls wear. Boots, pants, hooded parkas, and mittens were commonly made of seal and caribou skin to guard against the bitter arctic cold. The hunter carries a leather pack, sheath knife, and bow. The female doll, also equipped with a curved skinning knife, boasts three vertical tattoos on her chin—a common practice among Inuit women to indicate marital status, show courage, or simply to enhance beauty. In similar fashion, at age 12 or younger many boys and girls had a slit cut beneath the lower lip or at each corner of the mouth for a labret, or lip ornament.

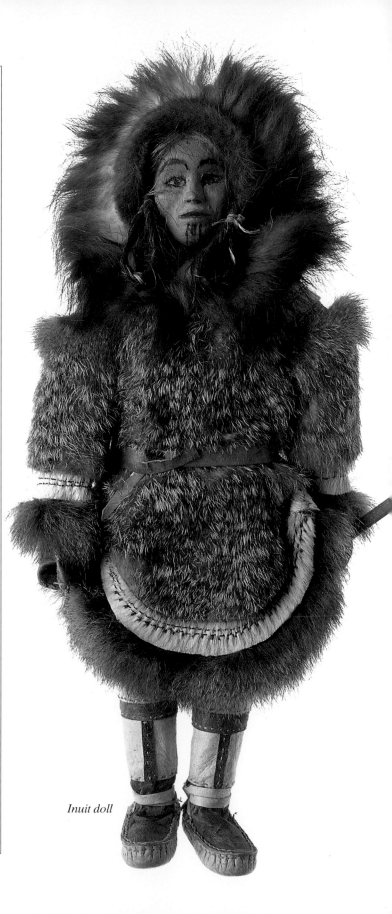

*Inuit doll*

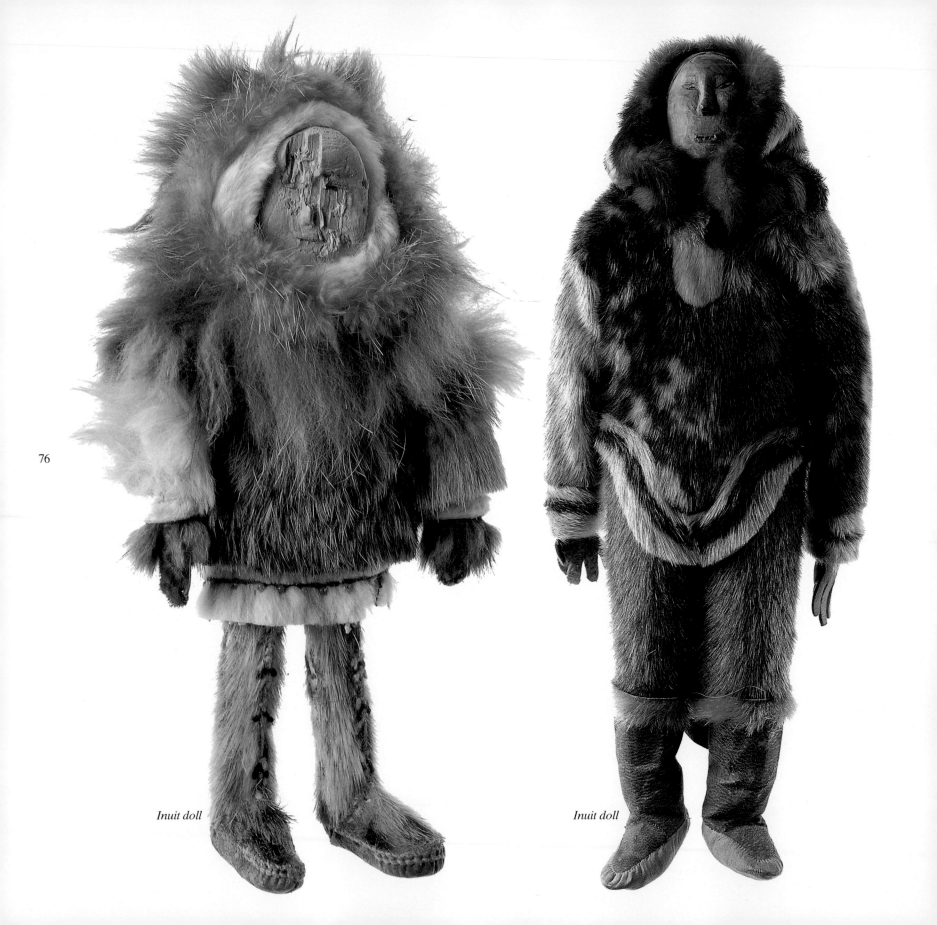

76

*Inuit doll*                    *Inuit doll*

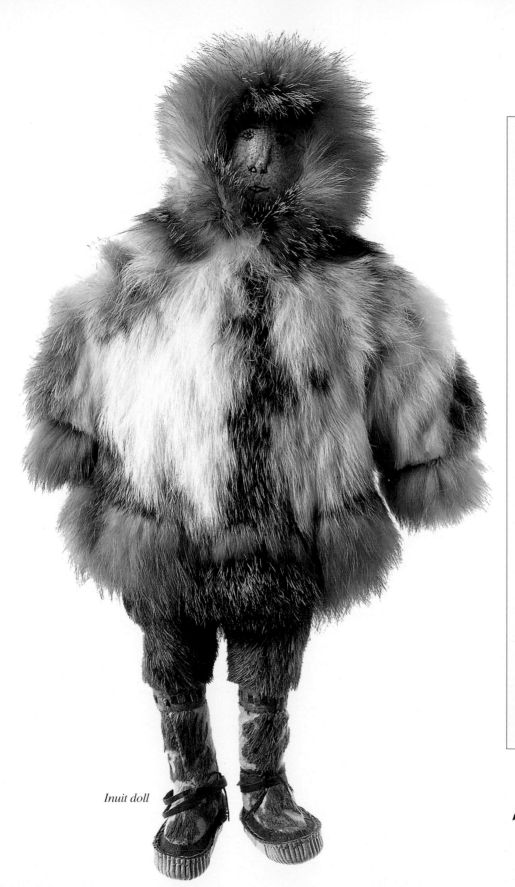

*Inuit doll*

**F**ur, sinew, and leather: these Inuit dolls wear native-style clothing made from seal, caribou, and other animals. Their makers took extra time to decorate many of the garments with different kinds and colors of fur, yet the purpose was not entirely decorative. For example, the hoods of parkas, when closed up tight, provide a kind of breathing tunnel which protects the face from the wind and pre-heats the cold air for easier breathing. This works well until the wearer's breath freezes on the fur ruff and threatens to close off the opening. The problem is solved by making the ruff of a soft, deep fur from which frost could easily be shaken. To this day many northern people prefer wolf fur above all others for this purpose.

77

Wherever there was forest, people made use of trees. Not just of the wood but of the bark, the roots, the sap, and the leaves. From Florida to Alaska, trees were used for houses, storage containers, all kinds of tools, ceremonial objects, and even cooking vessels. Perhaps the most graceful use to which a tree was ever put were the classic bark canoes of the Northeast. Yet it was the Northwest Coast peoples who developed woodworking to a high art, from elaborately decorated longhouses to carved waterproof boxes to totem poles and dugout canoes.

# THE LEARNING TREE

## A HAIDA TALE

All his life Quahu had been aware of two worlds, the forest and the sea. One seemed open and expansive but hid nearly all of its life in its depths. The other was dense, deeply shadowed, and also filled with unseen mysteries.

Sometimes he thought that if a man could float along the tree tops, 200 feet and more above the ground, it would be like drifting in a canoe on the ocean—the sky above, the tossing trees filled with animals

below. On occasion, birds would surface from the forest, fly a distance, then plunge back into the green, behaving like whales and porpoises when they leaped from the ocean.

If you looked at it one way, the sea and the forest were distant relatives but, as Quahu saw it, they were cousins.

His people, the Haida, lived exactly on the dividing line, the narrow cobbled beach between forest and sea. Their big wooden houses faced the open water, but hunkered down among the roots of the great trees. Whether the people launched their dugouts into the sea or walked back beneath the green, mist-wreathed canopy, they entered a world that was not quite theirs. Their only true home seemed to be the narrow beach. They were people of the margin.

Just now Quahu was working on the margin of a large cedar box. His father had built it years ago from one long plank scored across

the grain, steamed, and folded to make a rectangle. His father had fitted another slab of cedar to the bottom, so tightly that the box could be used to hold water. It once had had a lid, but that had broken, and Quahu was now replacing it.

From boyhood he had watched his father work with wood. Almost every aspect of the work was fascinating, especially the small-scale models his father made before attempting major works like totem poles. Among his earliest memories was the time his father took him into the forest to select a giant cedar for the building of a great whaling canoe. Once he selected the right tree, it would take a team of men several days to hew it down; then weeks more to burn and chisel out the interior, shape the hull, steam the gunwales, and force them wider with stout thwarts. Any boat was a big effort. One like this involved the whole community. Yet at the very beginning, on that first day

before the work of felling the tree had begun, Quahu's father had split off a separate chunk of cedar, and had given it to the boy to carry home. That winter, when the family had time to itself, he and Quahu together had carved a miniature canoe. It gave the boy a fine sense of belonging to the community.

As a famous carver in a society based on wood, his father had had strong feelings about his chosen material. "The sea is a great gift," he had said. "But the cedar is greater. The sea gives us food—the whale, the seal, the salmon—but the tree carries us across its treacherous surface. It clothes us, shelters us, gives us a place to stand, and after the hunt it brings us home."

And so it had done again, but not in a happy manner. Weeks ago his father had set out with a party of whalers in a new 60-foot canoe. All the right ceremonies had been performed. Their whaling leader had fasted for two nights, conducting the rituals of hunting magic. Yet they had seen no whales. Having been gone nearly a week, they had returned quietly, with no shouts of triumph, bearing no whale carcass upon which the whole community would feast. Instead they brought the body of Quahu's father and the sad tale of how the canoe, upon entering an estuary fifty miles to the south, had broached and overturned in the surf. Most of the men had survived. Several had disappeared. They had found only one body on the stony beach.

Tomorrow relatives of Quahu's mother would place his father in this box. They would seal it with the new lid and hoist it to the top of a mortuary column. There his father would lie, his presence declared by the carved family crest, on the margin between the forest and the sea.

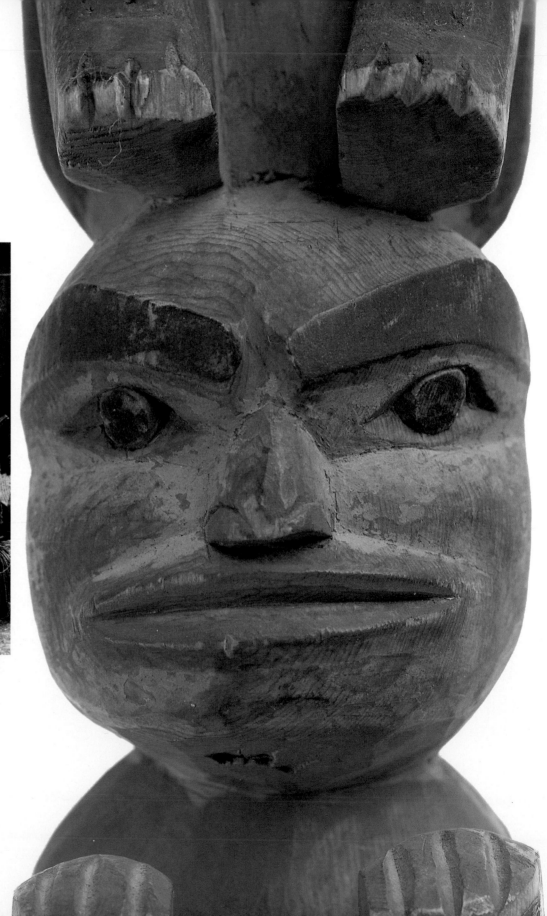

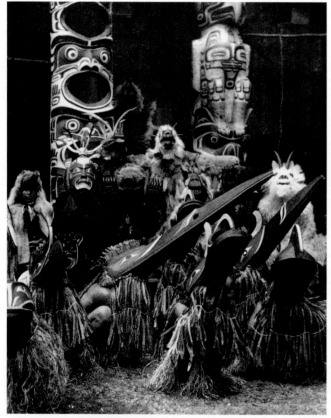

*Kwakiutl totem poles and dancers*

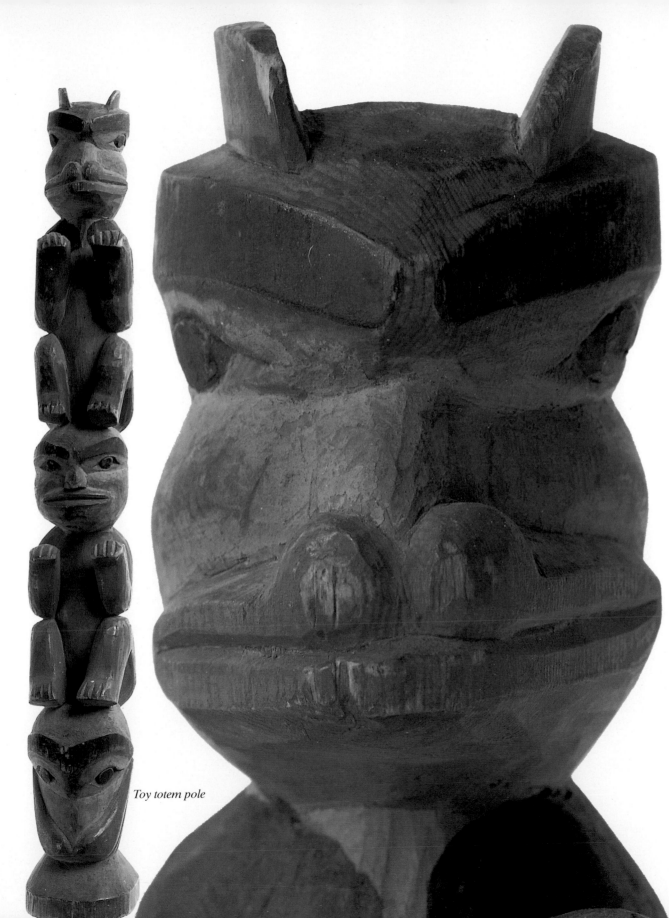

*Toy totem pole*

Towering above wooden houses all along the Northwest Coast, facing the sea from which came all visitors, totem poles proclaimed the status and property rights of village residents. Such poles were sacred. They reflected special relationships between families and animal spirits that even carvers had to respect. Unless he owned the right to carve a killer whale a carver could not create even a miniature like the one shown here. Used as a model for a full-scale version, the miniature bears three mythological guardians of the sea, including a killer whale at the base. Totems, whether on poles or dancer's masks, were central to the spiritual life of coastal people.

*Ojibwa canoes*

**F**our Ojibwa birch bark canoes lie on a rocky shore. In hundreds of years, no one has improved on the classic lines of these native craft. Birch bark was not the only material suitable for canoe-building. The Iroquois, who lived on the

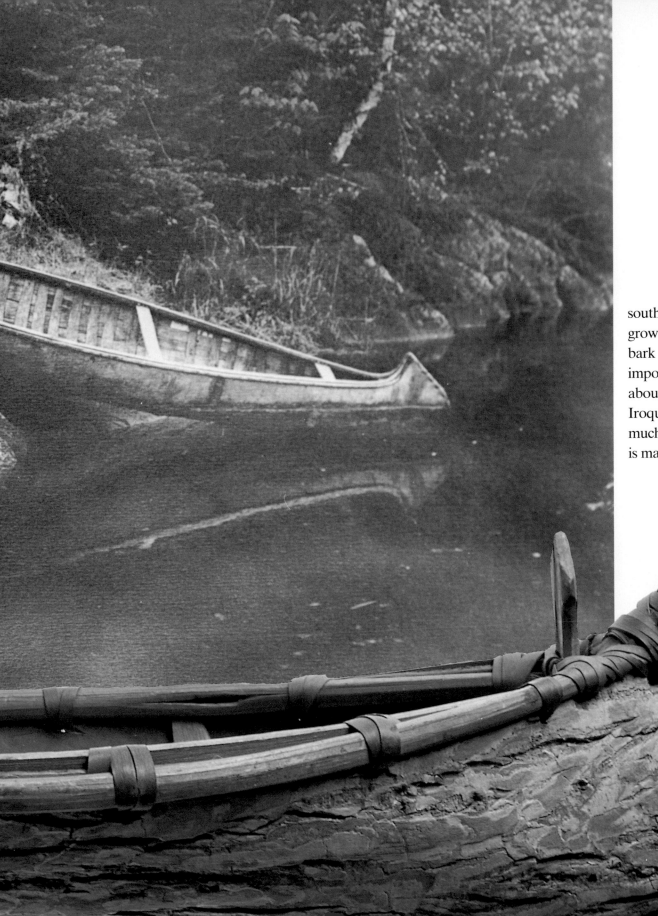

southern margin of good birch-growing country, often used elm bark instead. Since it was important that children learn about actual materials, this Iroquois miniature canoe, as much a toy as a teaching device, is made of elm bark.

85

*Iroquois toy canoe*

**T**he birch
tree was sacred to tribes near the Great Lakes.
Planted in the earth by the Creator, the
birch was given a knowledge of its own inner
structure and the magical properties of
its outer bark. In naming it, the Creator asked
the birch to take care of the people,
giving shelter and material for an abundance of

uses, none of which was more elegant or
demanding of craftsmanship than the canoe. To
build a canoe that handled well, stayed
dry, and was light enough for a single person to
carry across portage trails required years
of practice. All the important construction
details—for example, the lashing, the
ribs, and the cutting of bark pieces—are the
same as those on a full-sized craft.

*Chippewa toy canoe*

The trickster-creator known as Raven told the Northwest Coast tribes that man and animal were brothers and the land and sea was to be theirs forever. It was also on Raven's fine dugout canoe that people survived the great flood; appropriately, raven designs are carved into this miniature canoe and paddle. Before cutting a live cedar, a man would purify himself with water and speak to the spirit of the tree, saying, "We have come for you, to make you into a canoe." A boy learned such spiritual traditions, along with carving skills, from his maternal uncle.

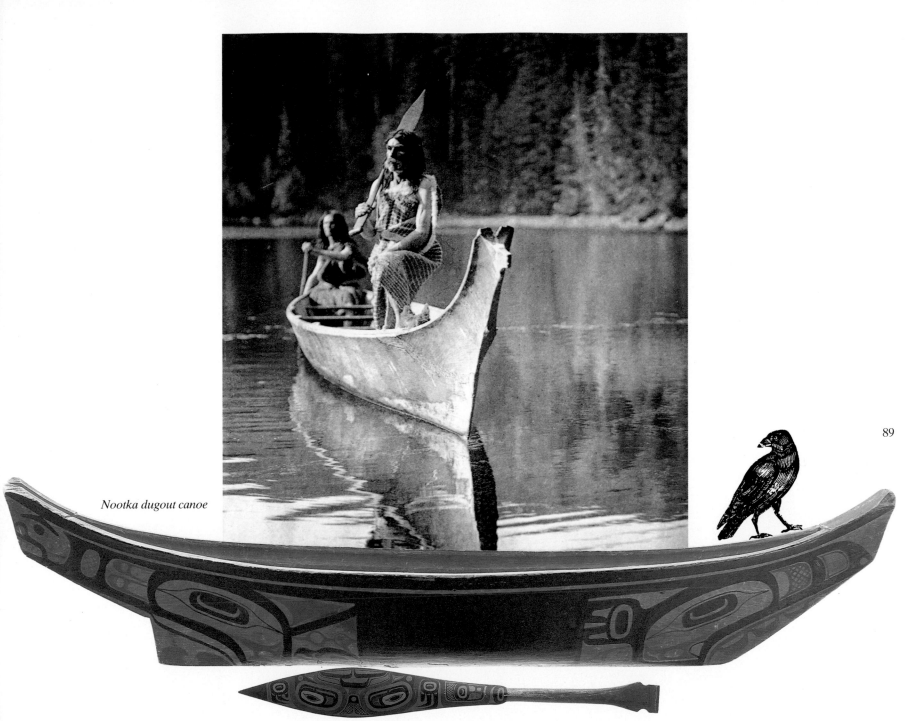

*Nootka dugout canoe*

*Tlingit toy canoe and paddle*

*Columbia River dugout canoe*

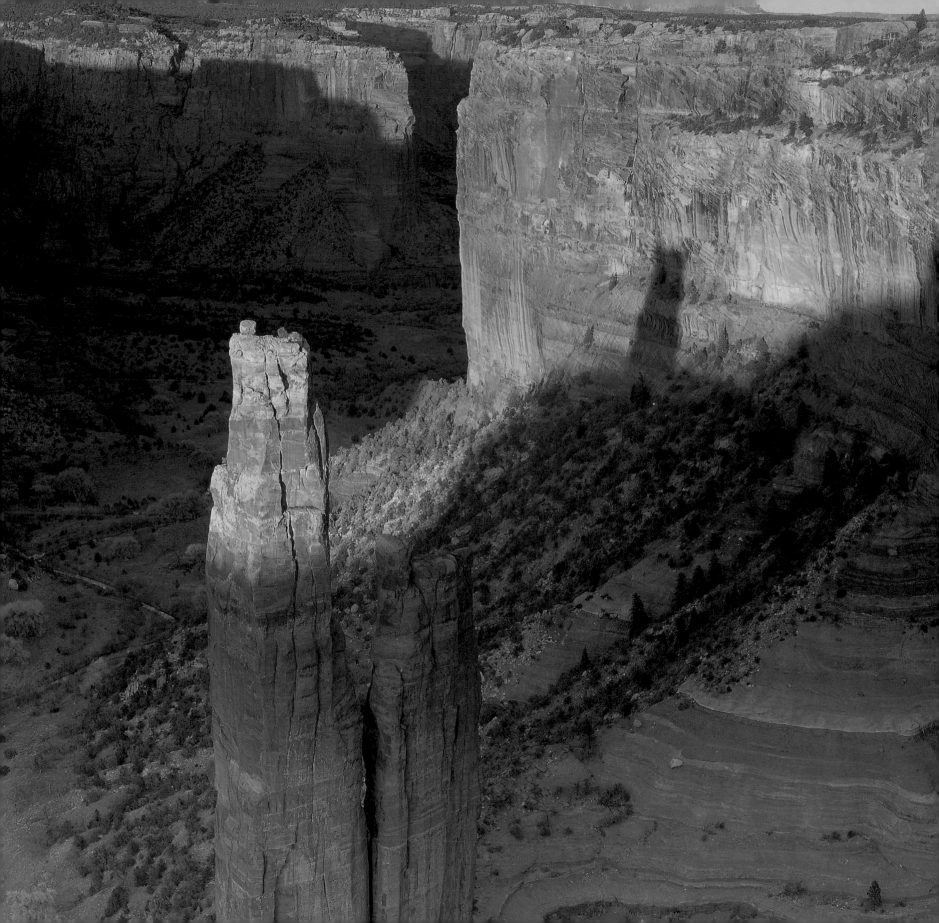

*The people of the Southwest have long had a feeling for woven fabrics, but none more than the Navajo. Although they learned weaving from their Pueblo neighbors, they soon carried the art to new heights, until today Navajo rugs made from handspun wool are famous around the world. For some time, the Navajos also made clothing from wool because it was the easiest fiber to obtain, but it was not the most comfortable material to wear, especially in hot weather. This changed quickly in the 1880s when white traders arrived with manufactured cloth and their wives showed Navajo women how to make dresses from calico and velveteen. Cotton fabric was inexpensive, easy to work with, soft against the skin, and cool in the heat of a desert summer.*

# SPIDER WOMAN'S WEB

### A NAVAJO TALE

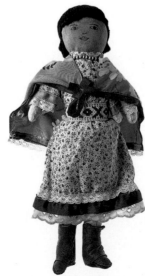

The first time she saw the trader's wife, Suzie Begay thought she dressed very strangely. Her brightly colored skirt flared from the waist down, and billowed in the desert wind— quite a sight compared to Suzie's simple garment. Made by her mother, it consisted of two flat pieces of woolen blanket joined along the sides and the top, leaving openings for her neck and arms. This simple tunic could be tied at the waist with a woven

belt, but, like most children, she rarely bothered with that last detail.

For as long as they could remember, The People (as the Navajo call themselves) had been skilled weavers. According to legend, they learned the craft from Spider Woman, one of the Holy People who lived atop a pinnacle in Canyon de Chelly. The Navajo weren't the only weavers. For centuries before they arrived in the land of red rock, the region had been home to Pueblo people like the Hopi and Zuni, who had a tradition of weaving native cotton and other materials on upright looms. Gathering and weaving was slow work back then. Fabric was rare and valuable. That changed in the early 1600s, when the Spanish arrived with domestic sheep and wool became the most important fiber for clothing, blankets, and rugs.

Suzie had seen factory-made cloth before but it was usually a heavy flannel in bright primary colors. Her mother sometimes unraveled a piece and incorporated its threads into a woolen blanket. Here was something quite different—roll upon roll of cotton cloth, stacked in the trader's wagon. He called it calico. Each roll was different: some were plain; others had printed patterns. The trader let her touch it, and the smoothness felt good against her skin.

Her mother thought so too, and eagerly traded some raw wool for a length of the new cloth. She spent the next several evenings making it into a big, billowy dress like the one worn by the trader's wife. It took yards and yards of fabric. In fact, it took every yard Suzie's mother had traded for.

How Suzie longed for a dress of calico! She asked again and again. "Wait until next year," said her mother, stroking Suzie's long hair.

"After the wool is cut there will be money."

This was not a satisfying answer. Like all little girls, Suzie was impatient. A year was an eternity. Worst of all, her mother didn't seem to care. In fact her mother sounded almost angry, ordering her out to look after the sheep. This was a child's job, of course. But Suzie knew everything there was to know about sheep and sometimes they could be the least interesting things in the world.

Sitting around the fire that evening in the hogan, Suzie felt no better. Her mother spoke curtly to her, sending her out for more fire wood. The wood had to be broken into little pieces, a long hard job. After that she had to haul water, and this seemed doubly unfair. Her brothers weren't hauling anything, and her grandfather, who usually doted on her, offered no comfort.

In the morning her mother ordered her out again for firewood. She and the rest of the family had funny looks on their faces, as if they knew a big joke and weren't going to share it.

Suzie took a long time getting the wood. If they were going to act that way, they could just wait or get it themselves. Finally, with the smallest load she could get away with, she came sullenly back to the hogan. Keeping her eyes on her toes, she stomped across the room and dropped her load near the fire. She looked up to find everyone giggling. Everyone except her mother, who sat calmly and formally by the fire. Beside her, dressed in the same calico, sitting just as formally, was a new doll. Both looked as if they were waiting for breakfast. Breakfast and Suzie.

The Holy
People who created the Navajo were strange and
powerful beings. They traveled on the
wind, rode the rays of the sun, and arrived in the
presence of rainbows, thunderbolts and
lightning flashes. Among them, Changing Woman
the Earth Mother taught mortals how to live
in balance with nature. She brought the gift of corn

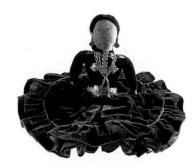

and built the first Navajo hogan, or six-sided
house, from turquoise. These were gifts to the
Navajo women, reflecting their central
position in the tribe's life. Also central is the
important celebration that marks a young girl's
transition from the world of toys and dolls to
the world of adults.

*Navajo doll*

**R**ed rock, ancient walls, and a people who have endured for thousands of years—the Hopi and other Pueblo tribes are as much a part of the southwestern landscape as the remains of their ancestors—houses, abandoned for 800 years or more. This Hopi doll wears the woven wool dress and squash-blossom (sometimes called butterfly) hair style of a marriageable young woman.

96

*Hopi doll*

*Pueblo ruins at Puerco*

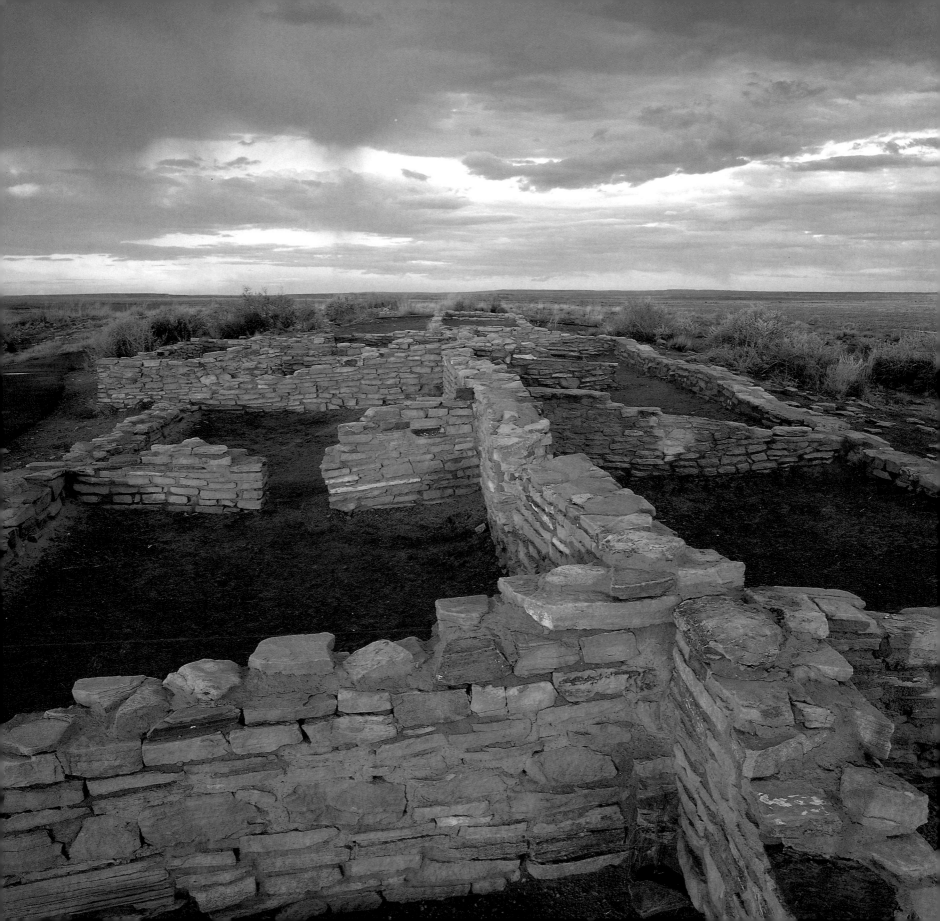

# C

hildren learned about the creation of the earth and the origin of people from stories told by adults—and by some fanciful beings as well. The ceramic toad storyteller figurine on the opposite page wears a painted squash-blossom necklace as a symbol of fertility. Little toads, apparently eager to hear stories, crouched all around her. The world of stories was peopled with delightful, child-pleasing creatures like those shown here. To the Pueblo people such animated figurines can represent the connection between human reproduction and other life-giving forms, linking one generation to the next.

98

*Cochiti clay animals*

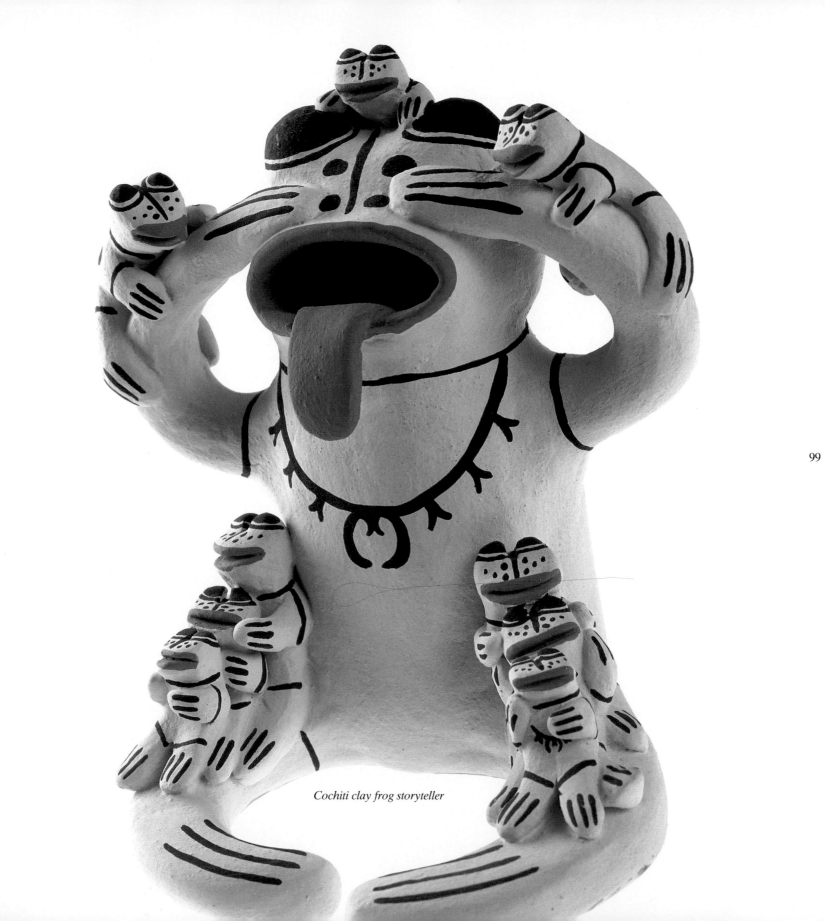

*Cochiti clay frog storyteller*

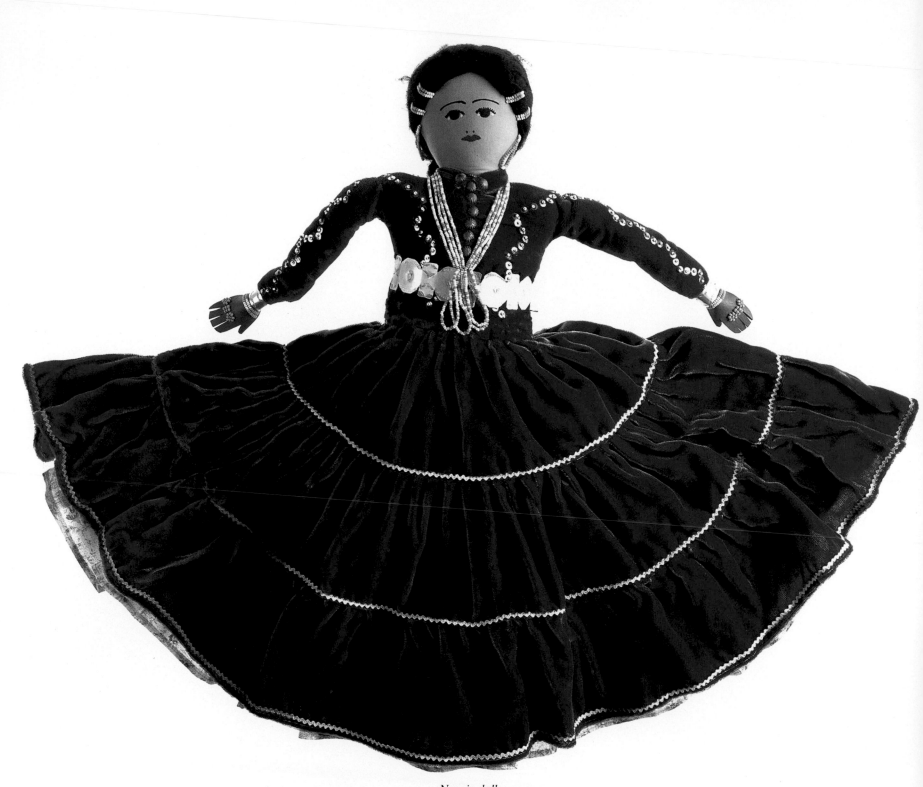

*Navajo doll*

The Navajo and Apache tribes belong to the same Athabascan-speaking group, and are linked with other tribes in the Canadian Subarctic. Both tribes arrived in the southwest about 500 years ago, joining Pueblo tribes like the Hopi, who had preceded them by a thousand years or more. The newcomers were nomads who lived mostly by conducting raids against their more settled neighbors. As nomads, they must have arrived with few material possessions, a condition that soon changed. These dolls, wearing their best calico, velveteen, beads, silver, and turquoise, depict how Apache and Navajo women dressed in the late nineteenth century after white traders introduced manufactured fabrics and other goods.

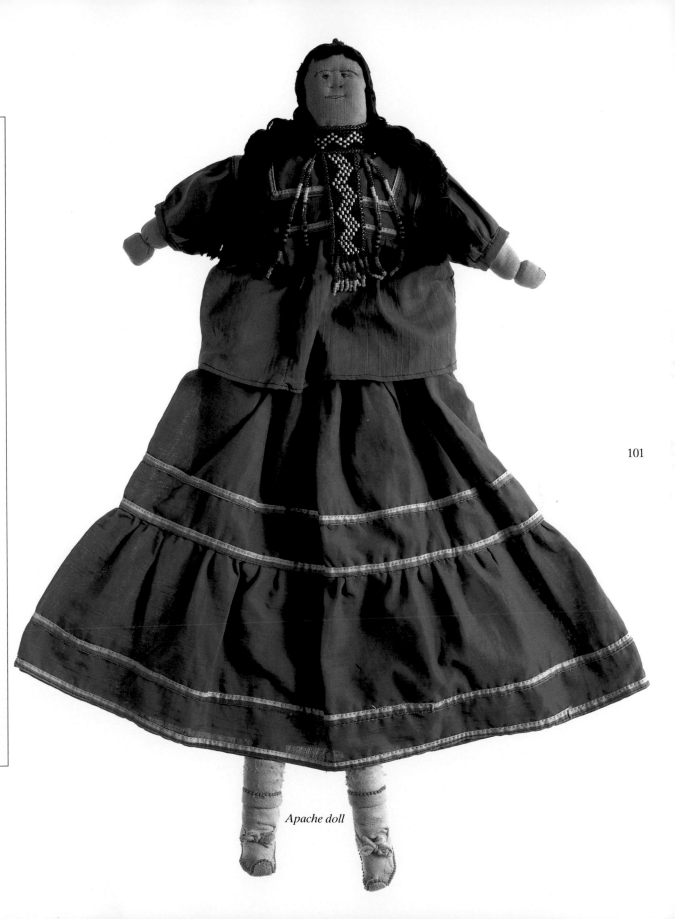

*Apache doll*

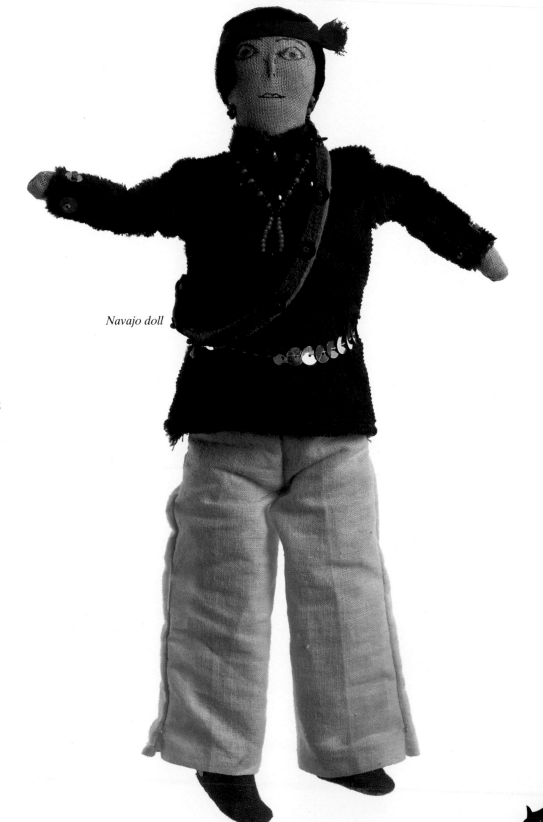

*Navajo doll*

102

**N**avajos are renowned for their ability to artfully absorb influences from other cultures—a talent derived perhaps from their homeland in northern Arizona, where Mexican, Pueblo, and European-American influences are all strong. Accordingly, these Navajo dolls reveal a Spanish influence in their velveteen shirt and blouse and the female doll's gathered skirt. The cloth came from American mills by way of trading posts. Both dolls wear their hair in buns, a style adopted from their Pueblo neighbors. Their jewelry includes sequins made to look like conchos—ornate silver disks, often attached to belts, which Navajo men learned to make from Mexican silversmiths.

*Navajo brave*

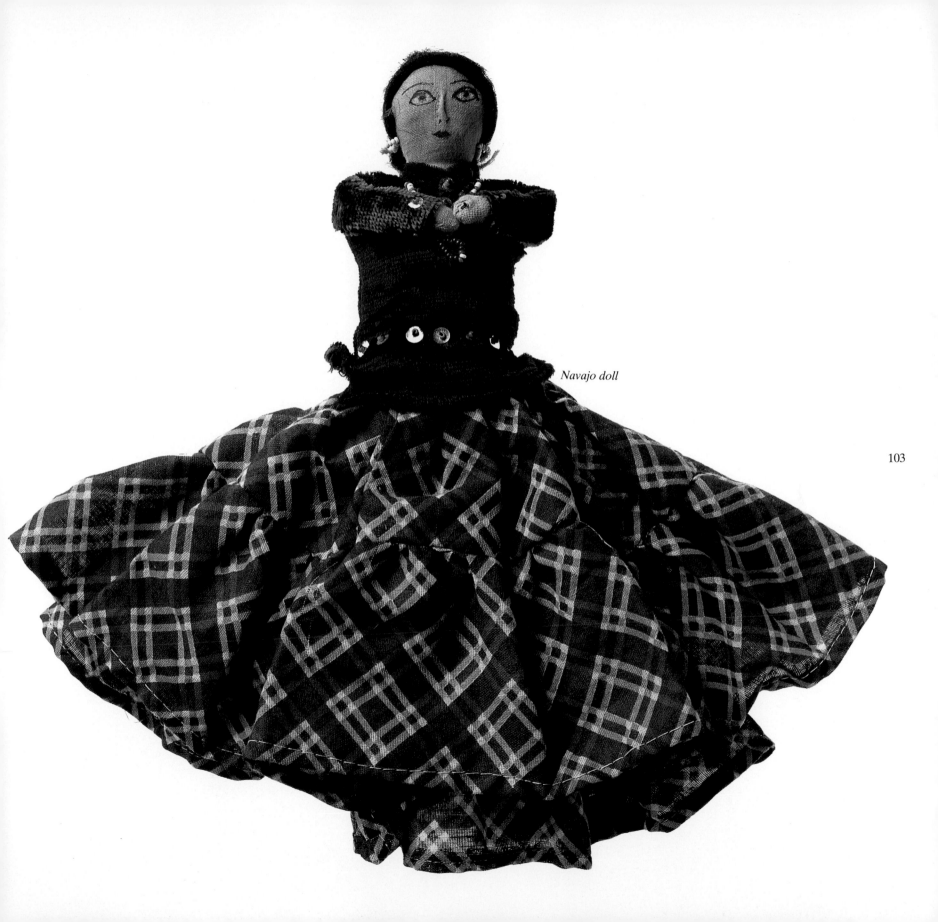

*Navajo doll*

103

*In the far North, where ice binds the sea through much of
the winter, and the summer, although blessed by a
sun that never sets, is painfully short, hunting meant
everything to native people. This was the work of
men, and from the time they were small, boys were given
small versions of hunting tools—toys designed to
teach the most critical of masculine skills. As soon as they
were judged able to risk the considerable dangers
(usually at around age 10) boys joined their fathers on real
hunts. To a large degree, the attitudes and techniques
developed in boyish play would determine both a man's
success as an adult hunter and his family's survival.*

# LOST IN A WORLD OF WHITE

AN INUIT TALE

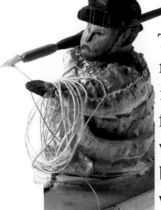

The calm sea stretched without a ripple to an invisible horizon— invisible because it formed a perfect mirror reflecting the dull white sky, and making it impossible for a man to distinguish where water ended and sky began.

This was the sort of condition Mugtuk had been taught to fear. Lost in a world of white, with nothing to focus his eyes upon, a hunter

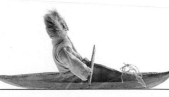

might go mad, and never regain his bearings.

Yet Mugtuk felt safe, for he could just make out the dark line of a rocky cape several miles to the north. And of all the men of his band, he was the greatest hunter and the best kayaker. In times of bad weather, when no one else dared venture away from the shore, Mugtuk went alone, confident and proud.

He also knew that his kayak was made with great skill. The sleek and silent craft, its deck floating nearly flush with the surface of the water, was capable of turning and gliding swiftly, then stopping with hardly a riffle. With its hide of sealskin stretched over a skeleton of wood and bone, waterproofed with seal oil, powered by muscle, the kayak so closely fol-lowed Mugtuk's intentions that it seemed to be a part of his body.

For some time now he had been riding the breast of the sea, paddling in short bursts toward a small cluster of seals. He had seen them from a distance, popping up their heads to breathe, looking about warily, then diving again. Moving only when no heads were visible, and freezing when the heads came up, he had closed the gap to just over a hundred yards without the seals sensing his presence.

His harpoon lay at the ready by his side, while on the deck a long sinew line was coiled, one end tied to the harpoon's detachable ivory point, the other end tied to an inflated sealskin float. Closer he came, closer. . . .

Suddenly there was great turbulence around his boat. The air filled with noise and mist from a vast exhalation. It was a whale! A whale surfacing to breathe. Anyone but Mug-tuk might have reacted too slowly. Anyone with arms less strong might have failed to drive the

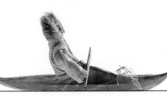

light sealing harpoon deep enough to have fatal effect, and anyone but the best hunter might have panicked in the ensuing chase as the whale sounded. There was reason to panic, for only too late did Mugtuk realize that the line had become fouled on the bow of his boat. He was being dragged underwater in the trail of the beast.

Down they went, deep below the surface into green water, Mugtuk holding his breath for what seemed an eternity. But he was determined, and, protected by his waterproof sealskin parka, he bravely held his paddle crosswise to slow and tire the whale. It took forever, but at last the whale surfaced again, and beside it the kayak popped to the surface. Mugtuk's lungs clawed for air. The whale would go down again but already it showed signs of weakness. This dive would be shorter, and Mugtuk knew

he would survive. He would win. He would take a whale single-handedly, a feat no other hunter had ever accomplished.

Down went the whale again, and just as the nose of the kayak dipped under the water, Mugtuk heard his father brush aside the flap to the family tent. The man stood for a moment looking down at the boy's arrangement of miniature kayak and sinew rope attached to a piece of seal blubber representing a whale. He recognized the adventure in progress. When he spoke it was with the serious face of a hunter but the inward smile of a father. "Mugtuk, I see you've been hunting. I am hungry. I hope you have had success."

How could Mugtuk explain about the whale? He said quietly, "Only a seal. Just a small one."

107

**B**ound together by the cooperative effort necessary for survival, northern families lived in close intimacy. Sometimes two or more families shared a single dwelling. For children, play and work were mingled. Every act had a serious side; every toy taught a lesson. This kayak model was probably made by a child, who covered its wooden frame with stretched seal gut stitched with sinew along the top edge. A carved ivory harpoon is linked to the kayak with a sinew line. The doll's face is carved from wood, while its parka is made of cotton fabric and seal fur.

*Inuit kayak and doll*

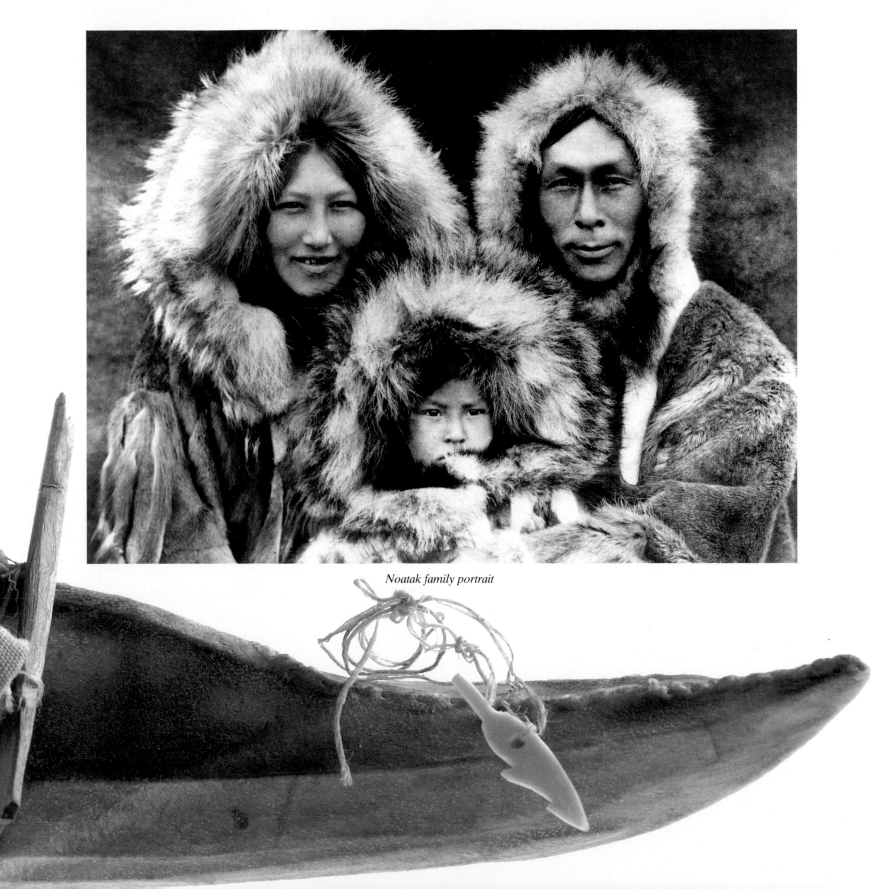

*Noatak family portrait*

109

**A**lthough
never the only means of transport in the
far north (and for the most part
replaced now by motorboats), the kayak has become a
universally recognized symbol of Arctic life.
Traditionally, the frame was made from driftwood or the bones of
sea mammals. A seal skin was
then scraped clean of hair, soaked in water to make it
flexible, stretched over the frame, and stitched tight

110

with sinew. When all the outside
stitching was complete, women reinforced the seam
with a second binding.
The final touch was a coating of seal oil
to make a smooth, watertight craft—easily carried and
nimble in the water. As this finely made
miniature shows, the same attention to detail was also
applied to toys.

*Inuit kayak and doll*

# Because

it allowed hunters to become almost like sea
creatures themselves, the kayak ranks
high among Inuit achievements. Seated on the
bottom, laced into his cockpit, the
hunter was one with his craft, able to tip over
and right himself without exposing
more than his face to the icy water. This soap-
stone miniature represents a successful
hunter returning home. He holds a double-
bladed paddle of wood. Around the
kayak opening are small incised circles to indi-
cate where he would lace his parka to
the boat. At the rear are attached two portions
of seal meat, while on the foredeck are
an inflated sealskin float and two harpoons.

112

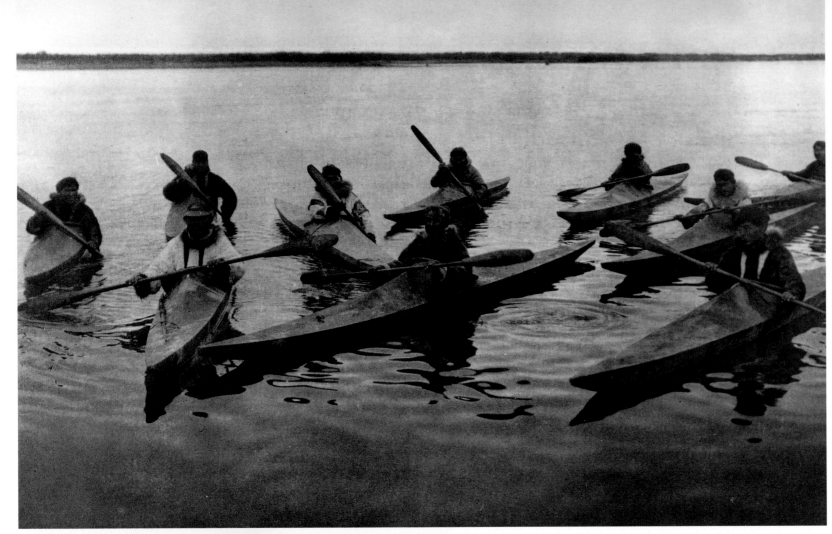

*Noatak hunters*

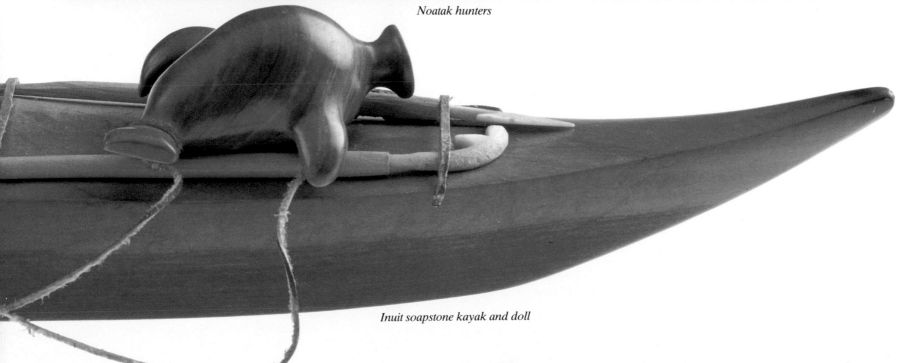

*Inuit soapstone kayak and doll*

# K

ayaks were built not just for the ocean. The Netsilik, among other people, used them on rivers to hunt caribou. They would make their camp upstream of a crossing place and wait for a migrating herd to enter the water. Then, moving swiftly and working together, the hunters would paddle among the animals and

*Inuit ivory kayak and dolls*

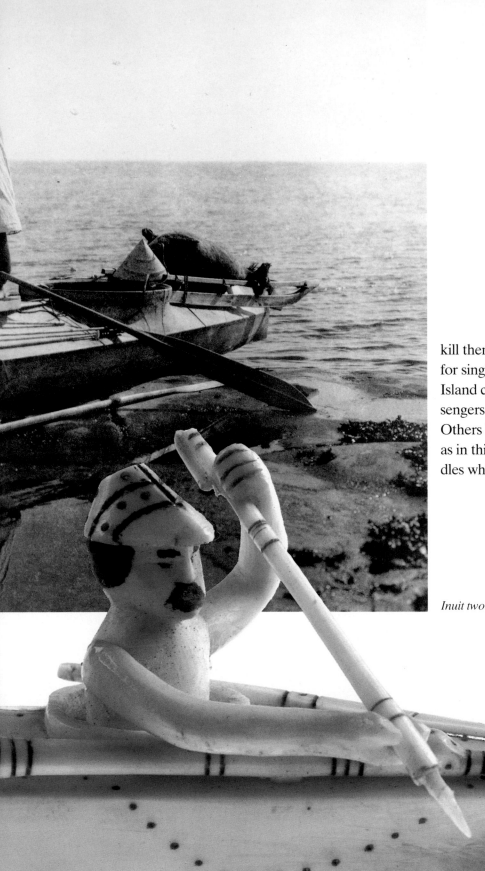

kill them with spears. Not all kayaks were built for single paddlers. The people of Nunivak Island crafted a two-man version with its passengers sitting back-to-back in a single cockpit. Others built kayaks with two separate cockpits as in this miniature ivory model. One man paddles while the other waits with poised harpoon.

115

*Inuit two-man kayak*

Early in a boy's life he joined his father and grandfather on hunting trips, sharing their hardships and their successes. Occasionally, armed only with knives lashed to poles, hunters speared polar bears weighing up to a thousand pounds. Another method of killing bears involved "death pills," frozen balls of seal flesh containing strips of sharpened bone wound up like clock springs. As the balls thawed in the bear's stomach, the bones would unwind and pierce it internally. The chief weapon and most important possession of an Arctic hunter was his harpoon, equipped with a detachable head of bone or ivory which was fastened to a sinew line and float. This carved model shows a man raising his harpoon. If well-thrown, it will mean death for a sea creature, but life for the man's family.

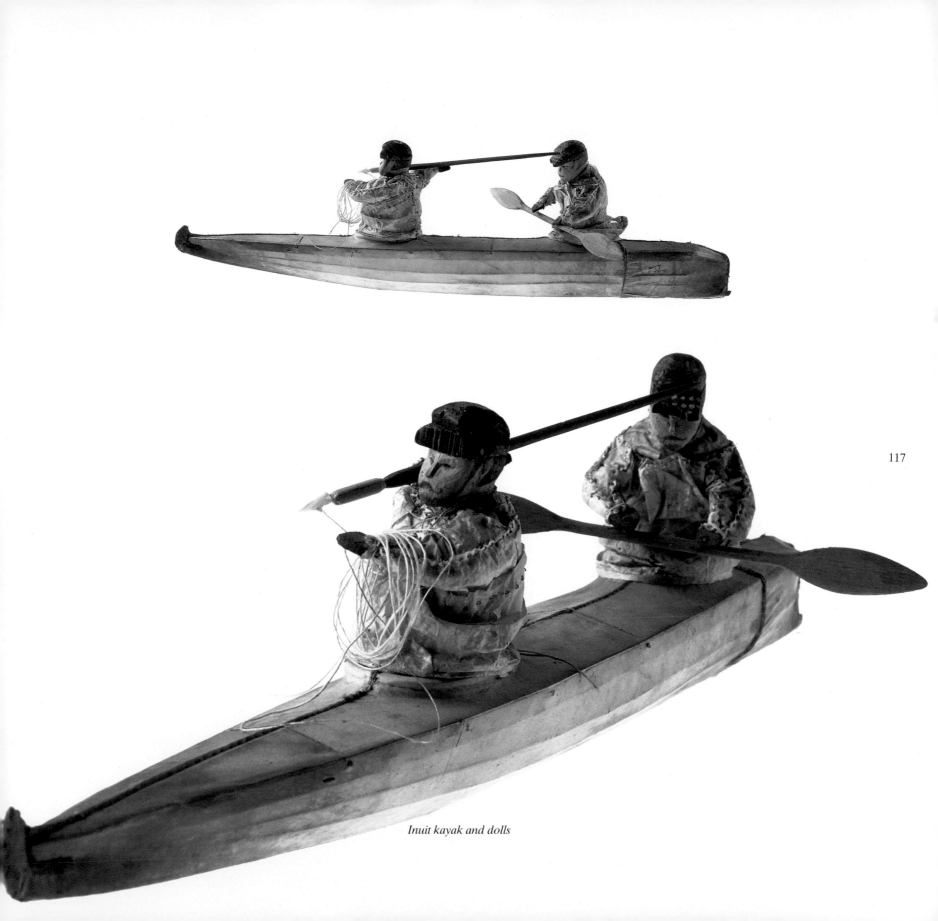

*Inuit kayak and dolls*

# INDEX TO THE ILLUSTRATIONS

The San Diego Museum of Man was the source of the artifacts in this book with the following exceptions. Artifacts on pages 30, 31, 36, 37, 47, 86–87, and 110–111 are from the Colter Bay Indian Arts Museum, Grand Teton National Park, Wyoming. Those on pages 72–73 and 120 are from a private collection. The artifacts and their museum identification numbers are listed below in the order in which they appear in the book.

Photo Credits

The San Diego Museum of Man (SDMM) was the source of the historical photographs in this book.

| Page | Identification |
|---|---|
| 6 | Vol. XVIII, p. 107, Edward S. Curtis, SDMM |
| 8 | Willard Clay |
| 10 | Plate 688, Edward S. Curtis, SDMM |
| 12 | Plate 621, Edward S. Curtis, SDMM |
| 13 | 2971, unknown, SDMM |
| 16–17 | 3049A, B, Detroit Photographic Co., SDMM |
| 20 | Pat O'Hara |
| 24 | Plate 22, Edward S. Curtis, SDMM |
| 26 | Plate 235, Edward S. Curtis, SDMM |
| 28 | 1677, Julia Tuell, SDMM |
| 28 | Plate 93, Edward S. Curtis, SDMM |
| 30–31 | 23070, Roland W. Reed, SDMM |
| 33 | Plate 270, Edward S. Curtis, SDMM |
| 34 | Plate 278, Edward S. Curtis, SDMM |
| 36 | 12617, Addison Studio, SDMM |
| 38 | Tom Till |
| 42 | 2929, Ben Wittick, SDMM |
| 44 | 2021, Detroit Photographic Co., SDMM |
| 46 | Plate 266, Edward S. Curtis, SDMM |
| 48 | Tom Till |
| 54 | Tom Till |
| 56–57 | 23772, Jo Mora, SDMM |
| 59 | 2009, unknown, SDMM |
| 60 | 23742-43, Jo Mora, SDMM |
| 62 | Pat O'Hara |
| 68 | Plate 694, Edward S. Curtis, SDMM |
| 71 | Pat O'Hara |
| 78 | Pat O'Hara |
| 82 | Plate 358, Edward S. Curtis, SDMM |
| 84–85 | 1350, Roland W. Reed, SDMM |
| 86 | Willard Clay |
| 88 | Plate 285, Edward S. Curtis, SDMM |
| 89 | Plate 386, Edward S. Curtis, SDMM |
| 90 | Tom Till |
| 93 | Plate 303, Edward S. Curtis, SDMM |
| 97 | Tom Till |
| 102 | 2211, Carpenter photo, SDMM |
| 104 | Pat O'Hara |
| 109 | Plate 717, Edward S. Curtis, SDMM |
| 113 | Plate 718, Edward S. Curtis, SDMM |
| 114 | Plate 695, Edward S. Curtis, SDMM |

# BIBLIOGRAPHY

Arthur, Claudeen, and Sam Bingham. *Between Sacred Mountains: Navajo Stories and Lessons from the Land.* Tucson, AZ: Sun Tracks and University of Arizona Press, 1982.

Brafford, C. J., and Laine Thom. *Dancing Colors: Paths of Native American Women.* San Francisco: Chronicle Books, 1992.

Clark, Ella. *Indian Legends of the Pacific Northwest.* Berkeley, CA: University of California Press, 1953.

Cohen, Caron Lee. *The Mud Pony.* New York: Scholastic, Inc., 1989.

Davis, Barbara A. *Edward S. Curtis: The Life and Times of a Shadow Catcher.* San Francisco: Chronicle Books, 1985.

Edmonds, Margot, and Ella E. Clark. *Voices of the Winds: Native American Legends.* New York: Facts on File, 1989.

Erdoes, Richard, and Alfonso Ortiz, eds. *American Indian Myths and Legends.* New York: Pantheon Books, 1984.

Gattuso, John, ed. *Native America: A Travel Guide.* Hong Kong: APA Publications, 1993.

Goble, Paul. *Star Boy.* New York: Bradbury Press, 1983.

Goble, Paul, *The Lost Children.* New York: Bradbury Press, 1993.

Hirschfelder, Arlene, and Martha K. de Montano, eds. *The Native American Almanac: A Portrait of Native America Today.* New York: Prentice Hall General Reference and Travel, 1993.

Houlihan, Patrick, Jerold L. Collings, Sarah Nestor, and Jonathan Batkin. *Harmony by Hand: Art of the Southwest Indians.* San Francisco: Chronicle Books, 1987.

Hungry-Wolf, Beverly. *The Ways of My Grandmothers.* New York: William Morrow and Company, 1981.

Josephy, Alvin M. Jr., ed. *America in 1492: The World of the Indian Peoples before the Arrival of Columbus.* New York: Vintage Books, 1993.

Laubin, Reginald and Gladys. *The Indian Tipi: Its History, Construction and Use.* Norman, OK: Univ. of Oklahoma Press, 1965.

Locke, Raymond Friday. *The Book of the Navajo.* Los Angeles: Mankind Publishing Co., 1989.

Marriott, Alice. *The Ten Grandmothers.* Norman, OK: Univ. of Oklahoma Press, 1983.

McLuhan, T. C. *Touch the Earth: A Self-Portrait of Indian Existence.* New York: Touchstone Books, 1976.

Millman, Lawrence. *A Kayak Full of Ghosts: Eskimo Tales.* Santa Barbara, CA: Capra Press, 1987.

Neihardt, John G. *Black Elk Speaks.* Lincoln, NE: Univ. of Nebraska Press, 1989.

Niethammer, Carolyn. *Daughters of the Earth: The Lives and Legends of American Indian Women.* London: Collier MacMillan Publishers, 1977.

Norman, Howard, ed. *Northern Tales: Traditional Stories of Eskimo and Indian Peoples.* New York: Pantheon Books, 1990.

Parsons, Elsie Clews, Barbara A. Babcock, ed. *Pueblo Mothers and Children: Essays by Elsie Clew Parsons.* Santa Fe, NM: Ancient City Press, 1991.

Parsons, Elsie Clews, ed. *American Indian Life.* Lincoln, NE: Univ. of Nebraska Press, Bison Book edition 1991.

Rasmussen, Knud. *The Eagle's Gift: Alaska Eskimo Tales.* Isobel Hutchinson, trans. Garden City, NJ: Doubleday, Doran, 1932.

Schmidt, Jeremy. *In the Spirit of Mother Earth: Nature in Native American Art.* San Francisco: Chronicle Books, 1994.

Smith, Anne M., ed. *Shoshone Tales.* Salt Lake City, UT: Univ. of Utah Press, 1993.

Standing Bear, Luther. *My Indian Boyhood.* Lincoln, NE: Univ. of Nebraska Press, 1988.

Taylor, Colin F., and William C. Sturtevant. *The Native Americans: Indigenous People of North America.* New York: Smithmark, 1991.

Thom, Laine. *Becoming Brave: The Path to Native American Manhood.* San Francisco: Chronicle Books, 1992.

Thomasma, Ken. *Pathki Nana: Kootenai Girl.* Jackson, WY: Grandview Publishing Co., 1992.

Trimble, Stephen. *The People: Indians of the American Southwest.* Santa Fe, NM: SAR Press, 1993.

Walters, Anna Lee. *The Spirit of Native America: Beauty and Mysticism in American Indian Art.* San Francisco: Chronicle Books, 1989.

Waters, Frank. *Book of the Hopi.* New York: Penguin Books, 1977.

Waters, Frank. *Masked Gods: Navajo and Pueblo Ceremonialism.* Athens, OH: Swallow Press, 1987

Acknowledgements

This book could not have been published without the assistance of the staff of the San Diego Museum of Man. Special thanks are owed to Grace Johnson, Assistant Curator, who helped us select the material, Ken Hedges, Chief Curator, and Stefani Salfield, Curator. Additional thanks are owed to the Teton County Historical Center and its staff: Larry Kummer, Director/Curator; Jo Anne Byrd; Rita Verley; and Amy Kissling. Finally, thanks to Linda Harrelson and Jill Holmes, who offered their personal research to us, and to Sharlene Milligan, Executive Director of the Grand Teton Natural History Association.

To some Native Americans,

the owl symbolizes death, to others it represents the widom of the ages.

But to all of us it is a bird of significance,

watching us follow the path of life.